3

4

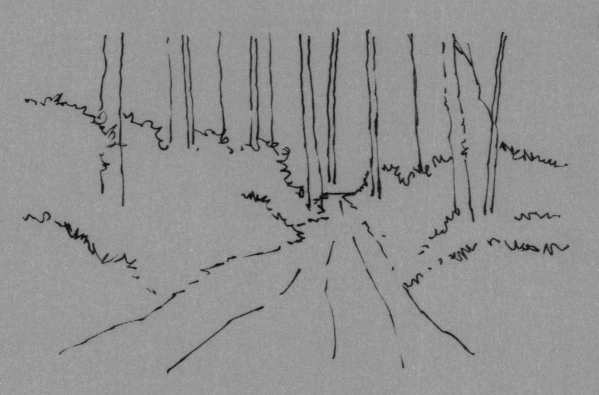

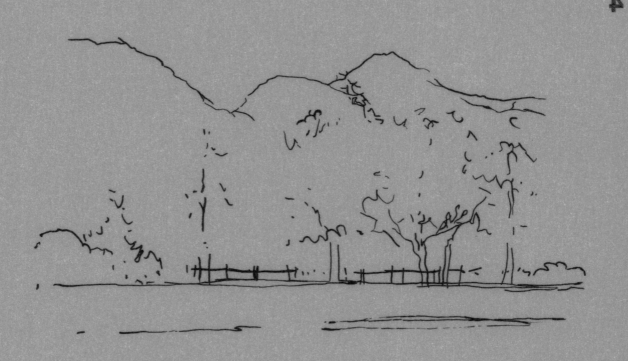

5

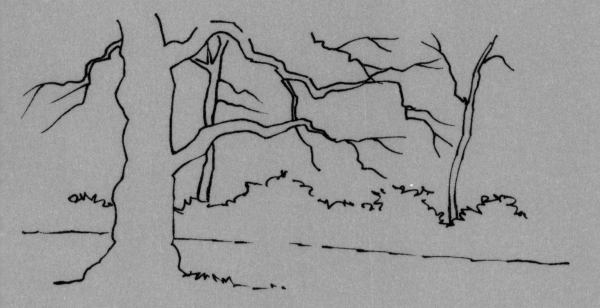

6

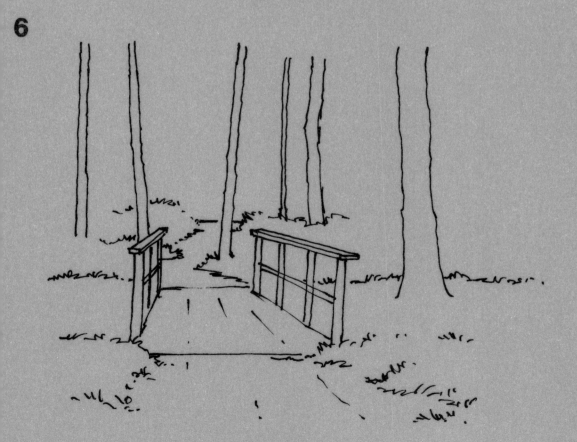

7

8

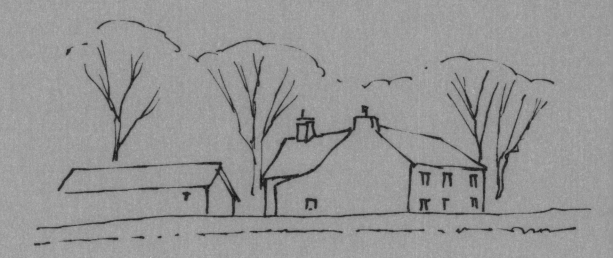

9

10

11

12

13

14

15

16

15

16

17

18

17

18

19

20

21

22

23

24

25

26

27

28

26

27

28

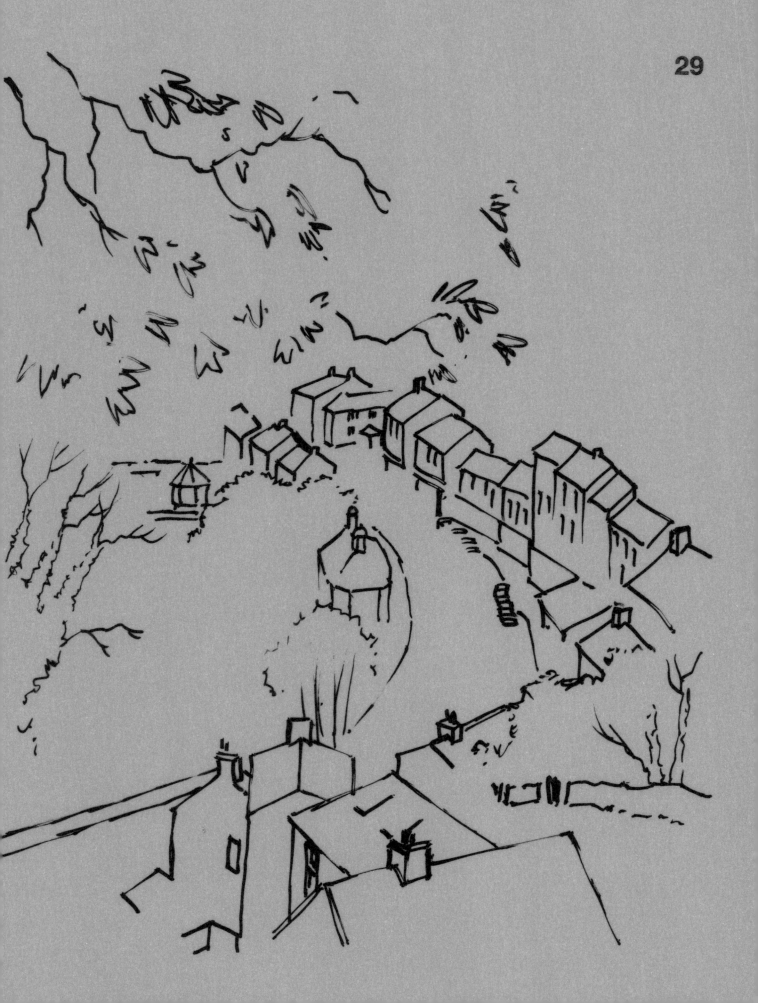

Ready to Paint in **30** minutes

Trees & Woodlands
in Watercolour

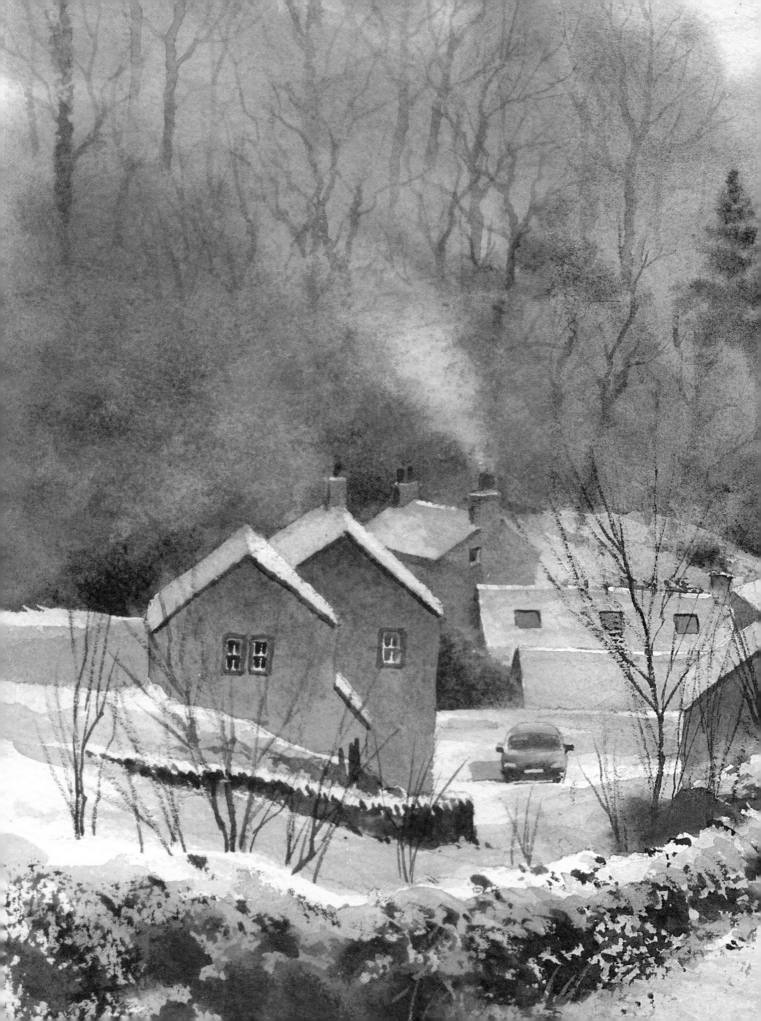

Ready to Paint in **30** minutes

Trees &
Woodlands
in Watercolour

Geoff Kersey

SEARCH PRESS

First published in 2018

Search Press Limited
Wellwood, North Farm Road,
Tunbridge Wells, Kent TN2 3DR

Reprinted 2018, 2019, 2020, 2021

Text copyright © Geoff Kersey 2018

Photographs by Roddy Paine Photographic Studios

Photographs and design copyright © Search Press Ltd 2018

ISBN: 978-1-78221-526-4

Suppliers
If you have any difficulty obtaining any of the materials and equipment mentioned in this book, please visit the Search Press website:
www.searchpress.com

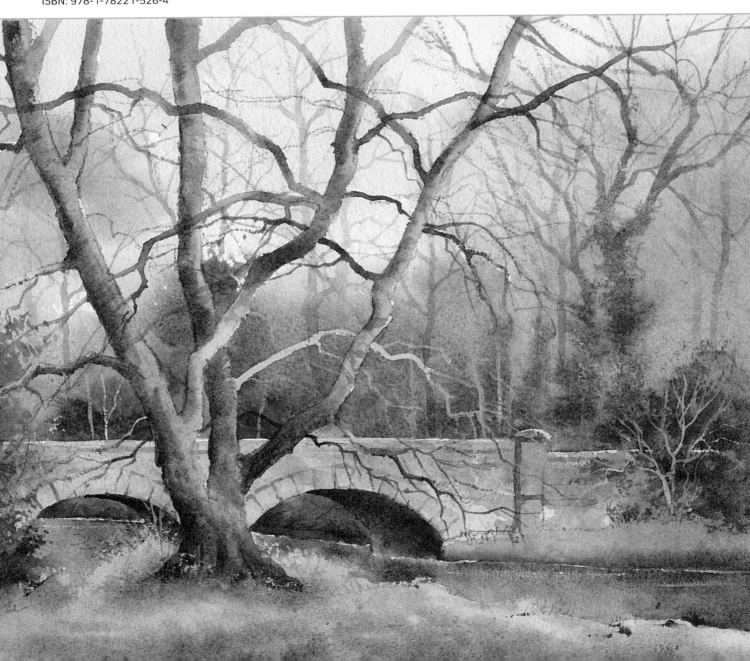

CONTENTS

INTRODUCTION

This book is a little different from those I have written before. It is made up of a series of short exercises, each worked on 15 x 10cm (6 x 4in) sheets of watercolour paper. Part of the reason for the small size of the pieces is to keep things quick – each exercise should take around half an hour. However, don't regard this as a strict limit. If you take a little longer, that's fine; just try to avoid labouring over them for more than an hour. Making a statement with your brush and paint over a short period, and then leaving it alone, is what this book is all about.

I wanted to include enough variety and interest in the exercises to be useful to any aspiring artist, so I have treated the theme broadly. Each of the exercises covers a different technique or subject that relates to the theme of woodlands – and not exclusively trees alone. I have explored trees as part of a variety of landscape scenes. Some exercises feature buildings or natural phenomena like rocks and geological structures, to contrast hard and soft shapes. In some examples we look at individual trees and in others a mass of undifferentiated foliage. There are subjects which are lit from different angles, sometimes looking into the light. You will find thorough explanations of colour mixing and tonal values, and don't worry if you aren't confident at drawing, there are tracings included.

I confess that when my publisher suggested the concept, I felt a little unsure at first – I always want my books to reflect my best work and thought the quick half-hour format would not offer enough to achieve that – but after making some little practice paintings that adhered to the discipline of both the time and size limits, I found I really enjoyed it and was pleased with the results. You will be surprised what can be achieved in the time. It is possible, even likely, that not every little painting will work out exactly as you hope, but as half an hour of painting is relatively easy to fit into even a busy day; you can give the exercise another go, by re-using the tracing.

All of this builds into a complete course that will develop your skills gradually and organically. Just by working through the exercises, you will create a collection of more than thirty small, complete paintings that you can display, and by the end of the book, you will find you are ready to spend the time to tackle the three more complex, involved projects at the back. These will put all you have learned into practice, and give you paintings that even an experienced artist will consider worthy of framing, exhibiting, or otherwise showing off.

Elterwater in Autumn
56 x 48cm (22 x 19in)

Autumn is 'the season of mists and mellow fruitfulness', and I have tried here to combine the soft misty shapes of the background trees with rich, autumn colours and warm greys. I found this scene when leaving Elterwater in the Lake District, UK, on a fairly steep footpath. I stopped several times to look back and take photographs. It was mid-afternoon in early November and I thought the colours and composition were perfect. I was looking into the light which simplified the shapes and tones, and was particularly drawn to the contrasting bright light on the cottage roofs, and the hint of smoke rising from the chimneys.

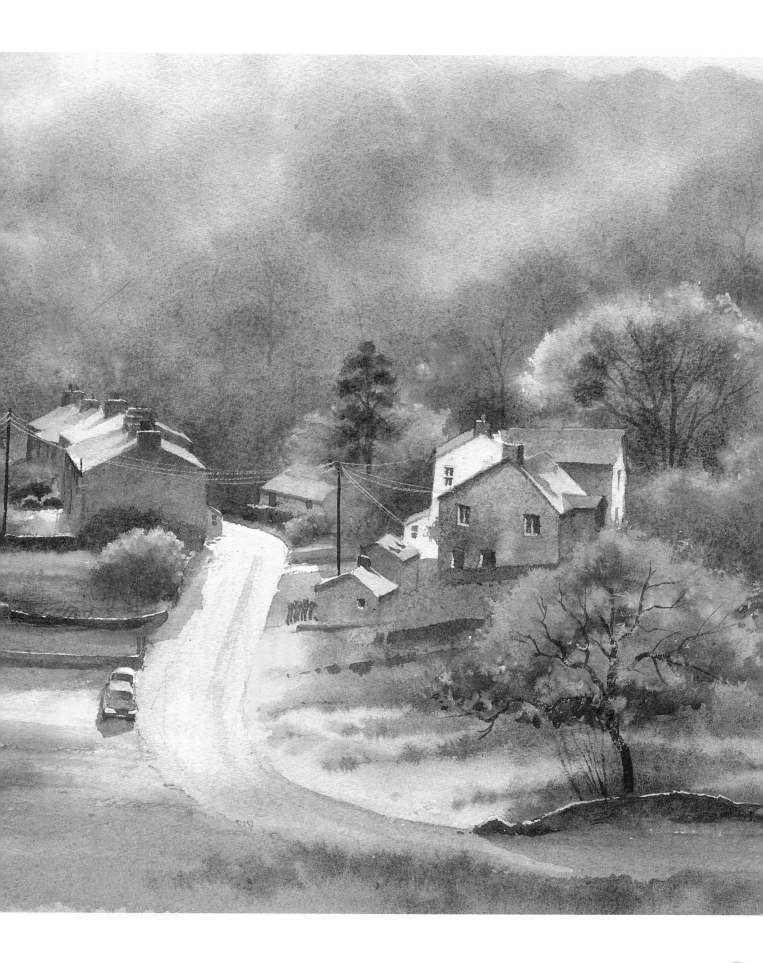

BASIC PAINTING EQUIPMENT

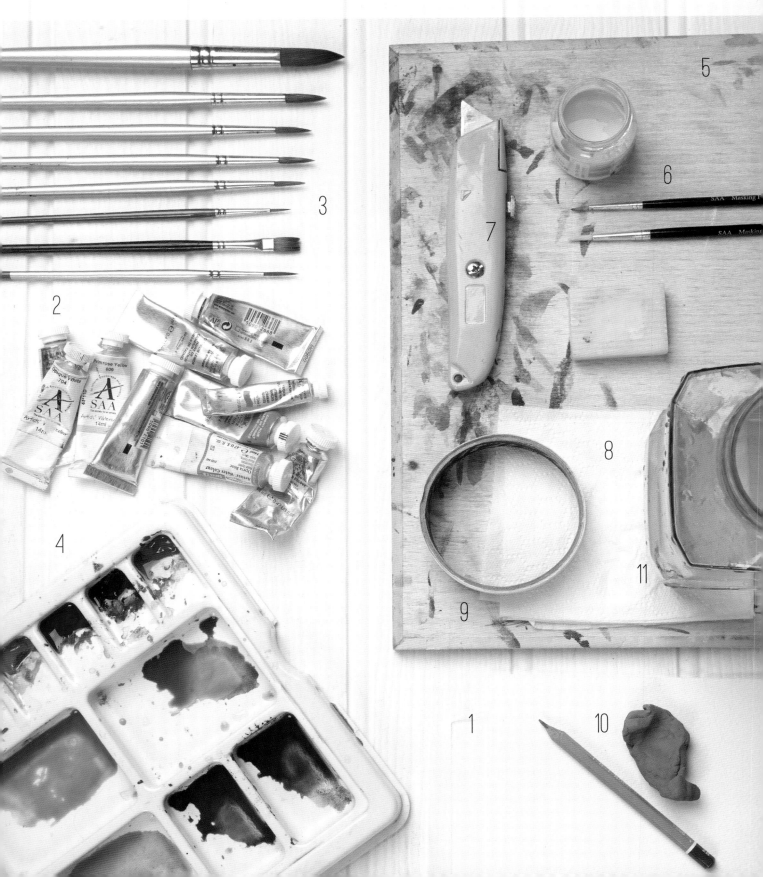

You don't need to spend a fortune to get started with watercolour landscape painting. However, having good quality kit at your disposal does make the job easier. As with many aspects of life, you get what you pay for. Whenever I am asked for advice on materials, I am careful to point out that it can be very much a matter of opinion, and the products that I have grown accustomed to using are not necessarily what other artists favour. Indeed there are many professional artists whose work I admire, but who work very differently from me, and favour a different range of materials. For what they are worth, these are my thoughts on the subject.

1 Paper I have put this first as, out of all my materials, the type of paper I use has the biggest impact on the finished product. I prefer the rag- or cotton-based papers to those made from wood pulp, as they are more durable. This is particularly important when using masking fluid. Rag- or cotton-based papers are more expensive, but have less size (starch or other substances that reduce the amount of water the paper will absorb) on them than many of the cheaper, wood pulp based papers. Too much size makes paper too resistant to the washes which feel as though they are just sitting on top of the paper surface.

The tracings and exercises are designed to use a postcard-sized – 15 x 10cm (6 x 4in) – pad of paper. A bit of tooth and texture helps to achieve many of the effects, so my favourite papers are Saunders Waterford's rough surface, and Arches Not surface (also referred to as cold-pressed) – I find that smooth, hot-pressed paper doesn't work for me. As for the weight, I prefer a heavier 640gsm (300lb) paper as this avoids cockling when the paper becomes wet. You can avoid cockling on lighter paper by pre-stretching, but I like the spontaneity of being able to pick up a piece of paper and start painting, without the preparation time.

2 Paints I use tube colour exclusively (as opposed to pans) as I find it much easier to mix, especially when I want quite strong, rich mixes. Although the cheaper Student's colours have improved over the years and you can now achieve a perfectly good result with them, I prefer Artists' quality paint to Students' quality as they have a greater ratio of pigment to gum, and consequently go further.

Buying Artists' quality paints won't cost a fortune. Avoid small 5ml tubes – the larger 14ml offer nearly three times the quantity for approximately twice the price.

3 Brushes This is an area where I think you can save some money. I personally prefer the springy nature of synthetic brushes, finding the natural hair brushes too absorbent and difficult to control. I use mainly round brushes, having a number 2, 4, 6, 8, 10 and 16 in my collection, together with 12mm (½in) and 25mm (1in) flat brushes. I also use a liner/writer for very fine work, like tree branches and long grasses.

4 Palette I use a palette I designed myself (see opposite) that I was fortunate enough to get put into production a few years ago. It is made of plastic with small wells for the fresh paint and large mixing areas. It has a lid and a sponge membrane which is dampened to keep the paint moist and workable between painting sessions.

5 Painting board Over the years I have built up quite a selection of drawing boards, most of them made myself from 12mm (½in) plywood. I do, however, like the lightweight drawing boards that are now available. I find chipboard doesn't take kindly to getting wet, while MDF is both too heavy and too dense to staple into – a method I sometimes use to secure the paper.

6 Masking fluid, brushes and soap I use masking fluid to protect certain areas, that I want to keep as crisp, clean white paper during the painting process. This means that when I get to these areas, I have a clean white background for my washes, rather than an area already stained with previous colours. You will soon see as you work through the projects in this book where I would choose to apply the masking fluid and why.

I use cheaper brushes to apply the masking fluid, as sooner or later they get 'gummed-up'. I dampen the brush and rub it on a bar of soap, before dipping it in the masking fluid; the soap acts as a barrier between the masking fluid and the brush, and consequently the brush lasts longer.

If your masking fluid brushes become gummed up, you can clean them by dipping them in lighter fluid or white spirit, both of which act as solvents.

7 Craft knife This is mainly used for cutting paper and scratching out effects.

8 Kitchen paper I always have a roll standing by to mop up accidents. It can also be used sparingly to create texture, by dabbing on the damp colour.

9 Masking tape This is most often used to hold the paper in position, but can also be used to mask out the edges, almost creating a mount effect around the edge of the painting.

10 Pencil and eraser I draw the subject prior to applying paint usually with a 2B, 0.9 mechanical pencil. I also have a 0.7 for finer detail. These aren't inherently better than a traditional pencil, but have the advantage that they don't need constant sharpening. I always use a putty eraser to remove or fade pencil lines as plastic stationery erasers can sometimes mark the surface of the paper.

11 Water Finally, you need clean water. Any large pot can be used to hold it, but rinse it out regularly to ensure the water remains clean.

Handling watercolour

This first exercise explains the very basic principles of watercolour, so even if you have never used watercolours before, you will quickly get up to speed by following the instructions and notes here. Take half an hour to get to grips with your palette and learn how different consistencies of paint act with the brush before moving on.

Note that this exercise includes information and an explanation of terms that appear in the later exercises, so even if you've painted before, it is well worth a bit of revision.

FILLING YOUR PALETTE

Each exercise is accompanied by a list of paint colours that you will need. Before you start, gently squeeze a small amount of each paint into one of the small wells in your palette (as shown below).

As you work, try to keep your colours clean to avoid muddying your paints. Use a clean brush to pick up pure paint from the palette well, and always mix in a larger mixing well, as shown opposite. If you do end up accidentally introducing another colour into a well, you can wipe the whole well clean and start again.

Watercolour goes a long way and can be expensive, so there's no need to squeeze out huge amounts — better to start with a small amount and add more to your palette well as you need it.

CHOOSING AND USING YOUR BRUSHES

As with the paint colours, the brushes you need for an exercise are listed at the start and explained in the text accompanying each step.

It may be tempting to try to use tiny brushes to get control over the paint, but this will result in a fussy, overly textural finish. Larger brushes hold more paint, so they allow you to create the smooth, luminous washes — see opposite — that are so attractive in watercolour. As a general rule, larger brushes are used for larger areas like skies (see below); while small brushes are reserved for finer details (see bottom).

Be sure to rinse your brushes thoroughly in clean water between using different mixes of paint — this is a most important point to make, as you will get dirty, muddy mixes by swapping between colours without cleaning your brush.

Technique: **Preparing your paint**

When preparing paint, use a wet brush to pick up the paint from the well, then deposit it in one of your larger mixing wells. You can then add more pigment, or more water to the mixing well to adjust the fluidity of the paint as shown in the steps here – don't start with a pool of clean water.

1 Prepare your paint by wetting your brush and picking up some paint from your palette. Transfer it to a clean well, then pick up clean water on the brush and add it to the well. Stir it gently to ensure the paint and water mix, but there is no need to scrub.

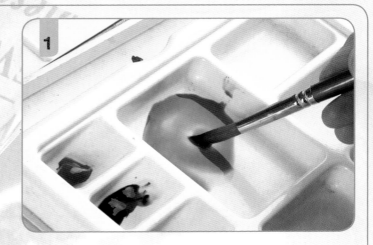

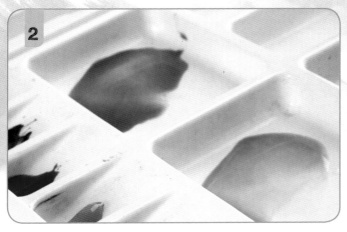

2 You can add more water to dilute the paint further and help you create lighter tints; or more pigment to create darker, deeper colour.

3 That's it! The only other thing to remember is that you can combine colours to create new mixes; this is part of the skill of watercolour painting. All you need do is add a different paint to the mixing area and stir it gently into the first.

WASHES AND CONSISTENCY

Most watercolour painting involves the application of washes. A wash is a thin, fluid mixture of paint and water, roughly the consistency of skimmed milk. Watercolour washes dry slightly lighter than they appear when wet, so take this into account when preparing them.

You will also need to use some thicker paint mixes for the exercises in this book, but even these are still diluted with a little clean water to help them flow smoothly. Make such mixes thicker than washes; each should be akin to full cream milk.

In a few rare cases, noted within each exercise, you may need to apply neat watercolour or gouache.

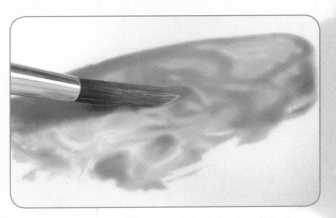

This green mix is slightly less dilute than a wash; you can see how the movements made with the brush remain apparent for a few moments before the paint flows back flat.

TREES THROUGH THE SEASONS

This section focuses on trees throughout the year, looking at the different colour palettes and the changes in foliage you need to paint them. Perhaps more importantly, it introduces a lot of the basic techniques that underlie the later exercises – so starting with these simpler exercises will not only leave you with some great little works of art, but will give you valuable practice in preparing and using your materials.

November Morning, St James's Park, London
35.5 x 25.5cm (14 x 10in)

There are some lovely autumnal colours here. I particularly liked the way the tall distant buildings are just suggested with a few light washes, and the way their angular, hard-edged shapes contrast with the soft shapes of the trees. For the really bright yellow/orange tree just to the left of centre, I used masking fluid on a wet background right at the outset. For instructions on how to do this, see page 22.

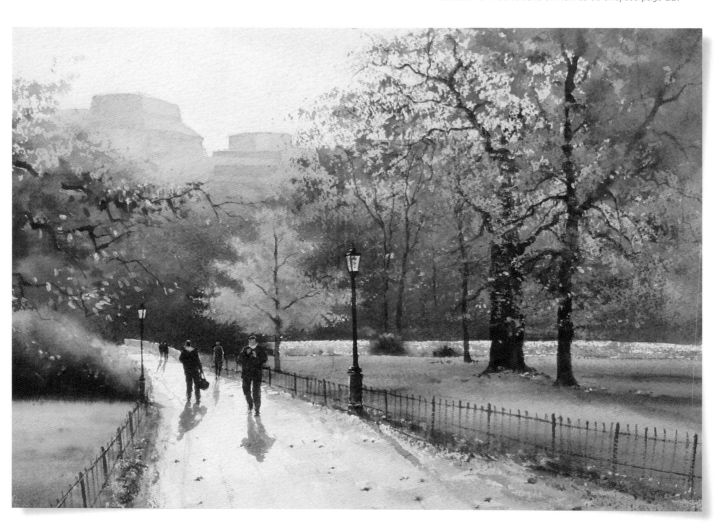

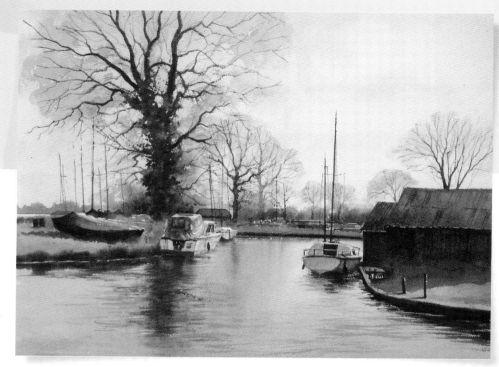

Hickling Broad, Norfolk

33 x 25.5cm (13 x 10in)

The bare, winter trees in this scene are as important a part of the composition as the boats and the water. The largest, most prominent tree in the middle distance on the left-hand side establishes a strong L-shaped composition. The other trees recede into the distance, gradually getting smaller and lighter in tone, until we reach the far distant ones, which are just small misty shapes.

Farm Pond in Early Spring

51 x 35.5cm (20 x 14in)

This little scene has some lovely spring colours, and I was particularly drawn to the thin trunks of the tall trees that extend across the middle distance. Because it is early spring there isn't too much foliage, so we can benefit from the gaps between the trunks and branches, which afford us a view of the distant hillside. Notice how I have used counterchange on the tree trunks, alternating between light and dark depending on the background.

YOU WILL NEED

Paint colours: cobalt blue, French ultramarine, raw sienna, burnt sienna, rose madder, viridian and lemon yellow

Brushes: masking fluid brush, size 10 round, size 16 round, size 4 round, size 2 round

Other: masking fluid, bar of soap, tracing number 1

Winter tree

This simple tree will get you started with some of the most important parts of painting trees with watercolour: preparing your paint and applying washes in different consistencies. It also shows you how to use masking fluid to preserve the white surface of the paper, and how to remove the fluid cleanly, too.

Technique: Applying masking fluid

Masking fluid needs to be applied in a certain way to avoid damage to your brush and to ensure that it properly protects the surface. If it dries in the bristles of the brush, it cannot be removed; so you should use a specific brush for applying masking fluid – either an old brush or a brush specifically set aside for applying the fluid.

1 Dampen the brush and gently rub the bristles of the masking fluid brush over a bar of soap. This will help to stop the masking fluid sticking to the bristles and spoiling the brush.

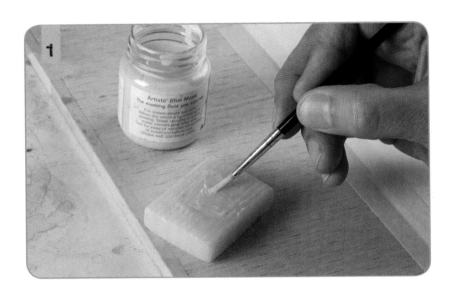

2 Add a fairly generous line of masking fluid beneath the top of the hedges. Anything under the masking fluid will be protected from the paint and remain clean until the masking fluid is rubbed away later. Allow the masking fluid to dry before continuing.

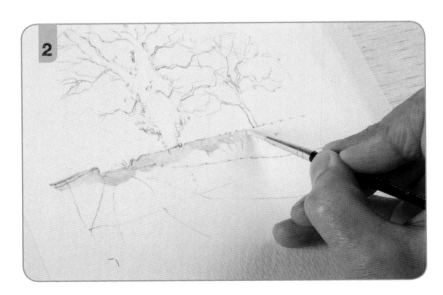

Technique: **Applying a wash wet-in-wet**

Wet-in-wet refers to adding wet colour onto still-wet paint. This allows the colours to bleed and blend together. You need to work fairly quickly to ensure the paint on the surface does not have time to dry before you apply the next colours.

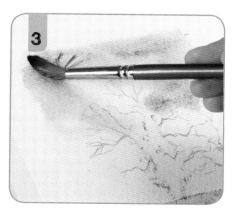 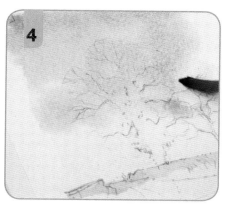 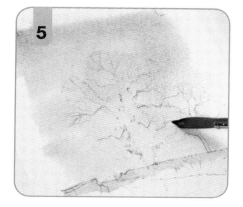

3 Prepare a dilute mix of cobalt blue and French ultramarine. Wet the whole upper part of the picture with clean water and the size 16 round, then pick up some of the sky blue mix and drop the paint in across the top of the sky area, working right over the trees.

4 Work downwards. As you approach the masking fluid, switch to the watery cobalt blue.

5 Work all the way down to the masking fluid. While the paint remains wet, rinse your brush and squeeze it gently to remove excess water. Gently touch it to the paint near to the horizon to lift away some wet paint and create a mottled, lighter effect to suggest clouds on the horizon. Rinse and squeeze the brush and repeat.

6 Add a little rose madder and burnt sienna to the watery cobalt blue to make a watery grey mix. Load a size 4 brush lightly with the mix then remove excess paint on scrap paper. Pick up and hold the brush with the thumb on one side, and all four fingers on the other.

7 Holding the brush like this allows you to get the whole side of the brush on the paper, rather than just the tip. As a result, when you lightly stroke it across, you miss the indentations of the textured paper surface and only hit the raised parts, creating a broken, leafy effect. Use this to describe the shape of the rightmost tree.

Technique: **Dry brush**

The dry brush technique relies on catching the raised texture of the paper surface, so it works best with a Not or rough surface paper. Be careful not to press too hard, or you will spoil the effect.

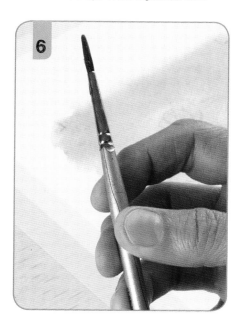 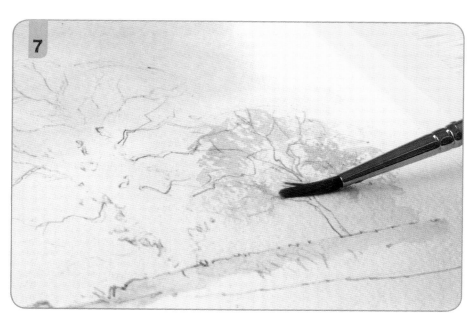

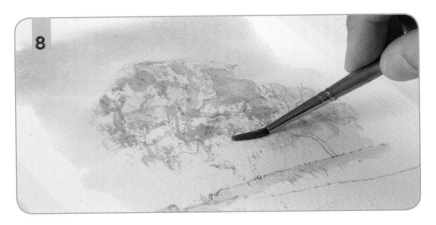

8 Paint both trees with the dry brush technique and a slightly thicker orange wash of raw sienna and burnt sienna. It is important that your brush is not too wet, or the paint will flow into the recesses of the textured surface and spoil the effect.

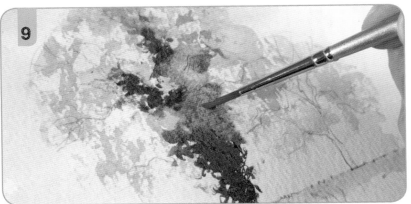

9 Make a creamy dark brown mix of burnt sienna and French ultramarine, and a dark green of viridian, French ultramarine and burnt sienna. Still using the size 4 brush, use the dark green mix to paint the main trunk of the larger tree. Do not paint in straight lines; use a wavering stroke and leave small gaps. Change to a size 2 brush and add some of the raw sienna and burnt sienna mix wet-in-wet. Rinse the brush and do the same with pure lemon yellow.

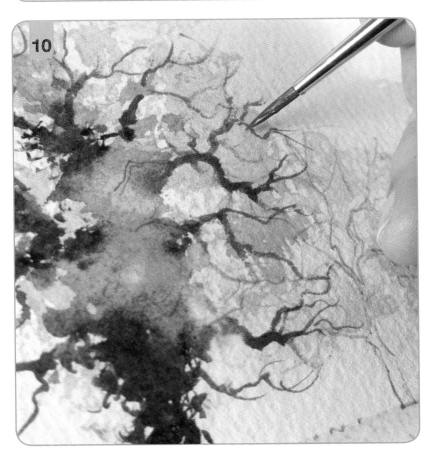

10 Working out from the main trunk you established, add finer branches with the very tip of the size 2 round brush and the brown mix of burnt sienna and French ultramarine. Allow the branches to taper off towards the edges of the tree, and take them to the edge of the dry brushed colour. Water down the brown mix to create lighter branches. This will give the impression that some of the branches are in the distance. Allow to dry.

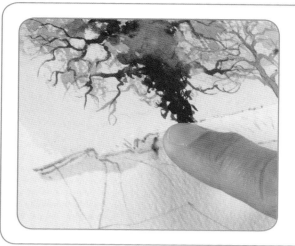

Technique: Removing masking fluid

Once the paint is dry, use a clean finger to gently rub away the masking fluid. It will lift away fairly easily.

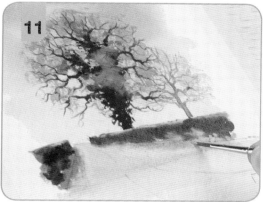

11 Paint the trunk and main branches of the distant tree with the grey mix. Being more distant, less detail is needed. Remove the masking fluid as described above, then paint the hedgerow wet-in-wet using the orange and brown mixes in your palette; and the road using the grey mix.

12 Once dry, use the size 4 round brush to make a purple mix of cobalt blue and rose madder. Use this to add some light horizontal strokes running across the road as shadows to finish.

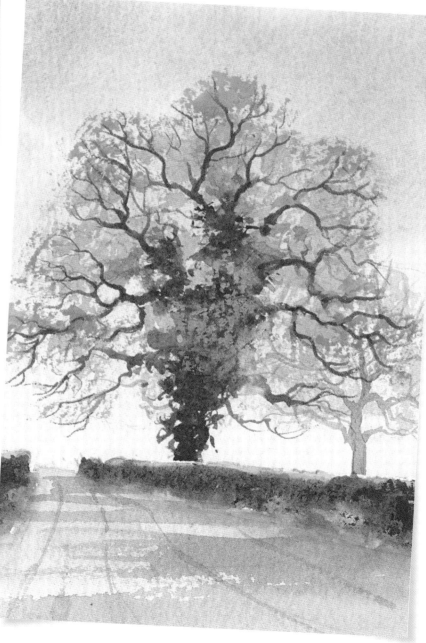

Autumn tree

YOU WILL NEED

Paint colours: cobalt blue, rose madder, lemon yellow, aureolin, burnt sienna, viridian, French ultramarine

Brushes: masking fluid brush, size 16 round, size 10 round, size 8 round, size 2 round, size 6 round, size 4 round

Other: masking fluid, bar of soap, tracing number 2

This project introduces the variegated wash, which allows you to quickly and easily create an interesting variation in colour across an area. As demonstrated here, it is perfect for describing the texture and complexity of distant foliage, but it has many applications more generally.

Technique: Variegated wash

This technique creates a varied mix of colours that is fantastic for suggesting distant, slightly out-of-focus foliage; perfect for trees and woodlands.

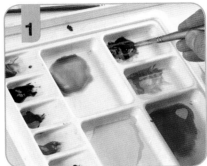

1 Mask the trunk and main branches of the large tree; ignore the smaller branches (see step 2). As the masking dries, make a thin purple wash of cobalt blue and rose madder; a thin wash of lemon yellow; a lightly thicker orange mix for autumn foliage from aureolin and burnt sienna; a bright green wash from aureolin and cobalt blue; and finally a dark green from viridian, French ultramarine and burnt sienna.

2 Wet the whole of the background with clean water and the size 16 round brush, except for the forest floor. Look for the shine on the paper to ensure you have covered everything, then paint the wet area with your first colour – lemon yellow in this case.

3 Working wet-in-wet and using the same brush, add the other colours (the autumn foliage and orange mixes) here and there, letting them bleed into the existing paint.

4 Add a little of the purple near the tree, then add the bright green around the bottom of the area.

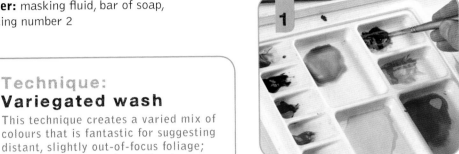

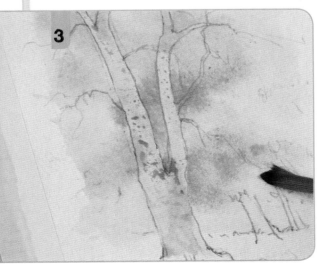

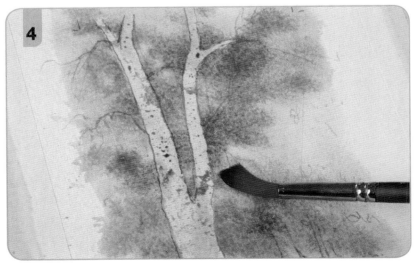

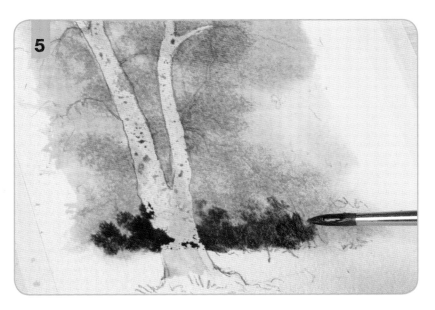

5 Add darker touches around the tree using the size 8 and the dark green mix, applying the paint with the tip of the brush and letting the paint soften in – if you time it correctly, the paint will largely do the work for you. If it starts to run away out of control, wait a moment for the background to dry a little before trying again.

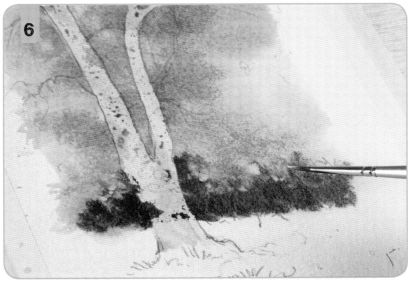

6 Pick up some pure lemon yellow – either from the tube or from your palette well – and touch in some highlights at the top of the dark area with the tip of the size 2 brush.

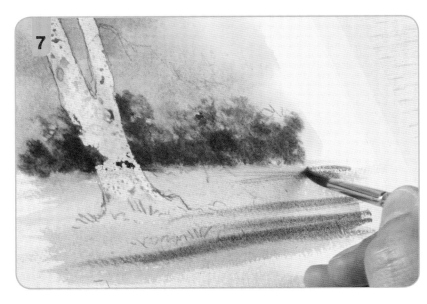

7 Change to the size 10 round and use long sweeping strokes to paint the grasses in the foreground with the bright green mix (aureolin and cobalt blue). Paint beyond the edges of the picture, to ensure you fill it evenly. Add some aureolin highlights as in step 4, then change to the size 6 brush and add shadows with the dark green mix; again making fairly horizontal strokes.

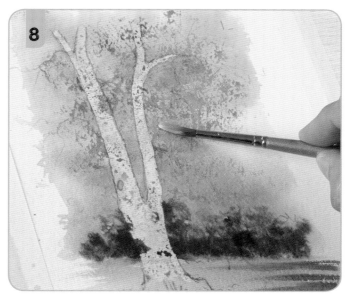

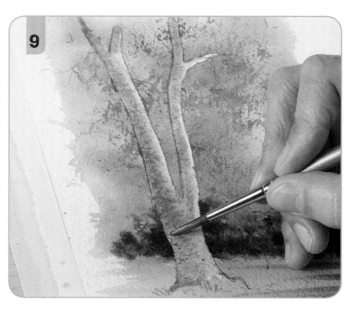

8 Once it has dried, use the dry brush technique to paint over the main branches of the tree with the orange mix (aureolin and burnt sienna) and then the purple mix (cobalt blue and rose madder). This will create masses of leaves quickly and without having to paint each leaf individually. Add some sunlit leaves in the same way using lemon yellow. Once dry, use a clean finger to remove the masking fluid.

9 Wet the whole tree with clean water, using the size 6 round, then build up a variegated wash by adding the bright green mix, very diluted. While wet, add touches of the purple mix and orange mix here and there.

10 In order to make the tree look cylindrical, add stronger, darker tones on one side as shadows. Use the size 4 to add a dark mix of burnt sienna and French ultramarine wet-in-wet. Do not aim for a clean effect, or the tree will look unnatural, like a pipe. Adding a little texture makes it appear weathered and naturalistic. Add some very light-toned colour – lemon yellow – on the opposite side as a highlight.

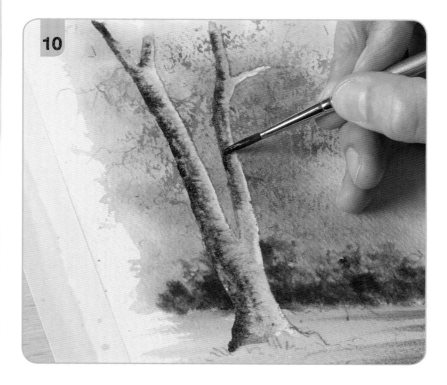

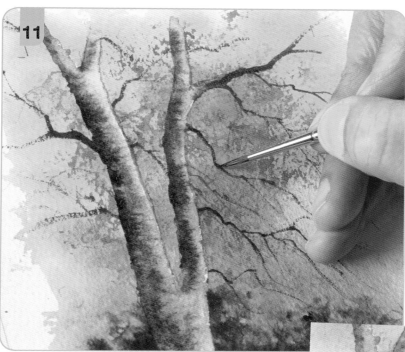

11 Change to the size 2 round brush and the dark mix (burnt sienna and French ultramarine) to paint in the finer branches, working outwards from the trunk and lifting it away to create a tapering, fine effect.

12 To finish the painting, a mix of neat lemon yellow and burnt sienna can be worked over the surface using the size 4 round brush and the dry brush technique to create the impression of leaves in front of the trunk. Add a few small dashes – not dots, which can look unnatural – of the same mix to create a few individual leaves in the foreground with the size 2 brush. Anchor the tree to the ground by using the same mixes as the trunk to soften it into the dry grass area, then use the dark mix to create a shadow on the left-hand side.

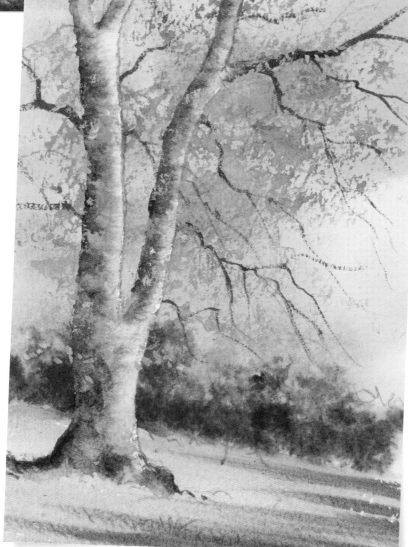

YOU WILL NEED

Paint colours: lemon yellow, aureolin, cobalt blue, viridian, French ultramarine, burnt sienna, cerulean blue, cobalt violet, raw sienna, primrose yellow

Brushes: masking fluid brush, size 10 round, size 16 round, size 4 round, size 6 round

Other: masking fluid, bar of soap, tracing number 3

Spring trees

This project introduces feathered masking, a technique that allows you to use masking fluid that flows a little like paint in order to achieve soft edges. Once dry, this will help to create a soft, feathered edge to the area, rather than the usual hard edge.

It also introduces the use of body colour – opaque paint, which enables us to paint over the top of existing work: very useful for certain effects. The paint used in this example, primrose yellow, is essentially lemon yellow with a touch of white gouache added, so you can mix a version of it yourself if you cannot find the premixed primrose yellow.

Technique:
Feathered masking

This technique avoids the hard lines that masking fluid normally leaves; instead creating a softer effect. Be careful to wet more than you need – once the masking fluid reaches the edge of the water, you'll get a hard edge: just what you're trying to avoid.

1 Wet the area around where you want to mask – in this case around the base of the tree. While wet, use the masking fluid brush to drop in masking fluid as normal.

2 Mask the path as normal for masking (see page 14) before continuing. This will help to illustrate the difference in effect later.

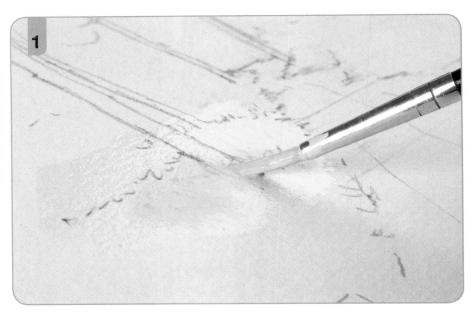

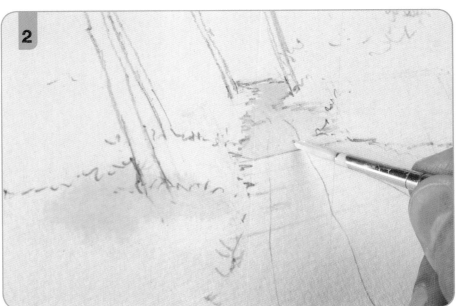

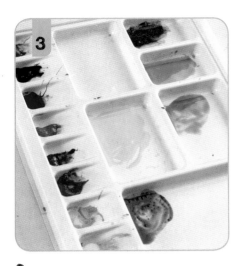

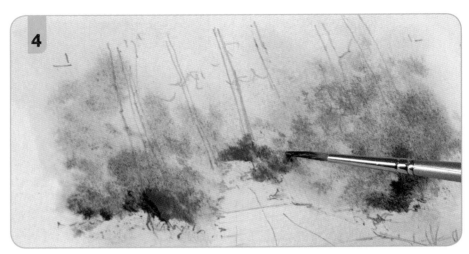

3 While the masking fluid dries, prepare your colours. Make a thin wash of lemon yellow; a thicker bright green mix of aureolin and cobalt blue; a dark green mix of viridian, French ultramarine and burnt sienna; a wash of cerulean blue; and a green-grey mix of viridian and cobalt violet.

4 Wet the whole of the background – not the path or foreground – with clean water using the size 16 brush. Make a variegated wash over the area by laying in lemon yellow with the side of the size 10 brush, then add touches of the bright green mix, then the grey-green mix. Keep the grey-green mix towards the bottom of the area, and work right down to – and onto – the masking fluid. Change to the size 6 round brush and add some cerulean blue touches while the paint remains wet. Finally, change to the size 4 round and paint in denser areas of foliage with the dark green mix. Add these near the areas of masking fluid – this will create maximum contrast with the white of the paper when the masking fluid is later removed.

5 Once dry, break up the foliage with the dry brush technique and the brighter colours – the lemon yellow and the thicker bright green mix (of aureolin and cobalt blue).

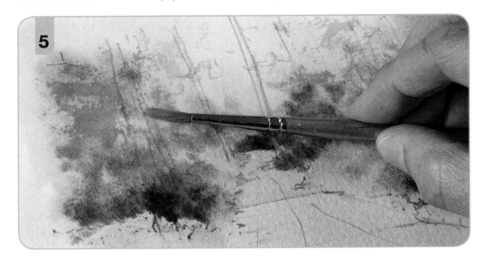

6 Continue building up the texture in the foliage using the medium-toned and dark-toned mixes with the dry brush technique. Be more sparing with the darker tones than the lighter ones; be careful not to cover the brighter touches you have just added. Do not overwork this dry brush technique: keep stopping and asking yourself whether you have done enough.

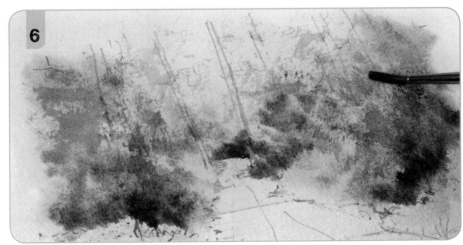

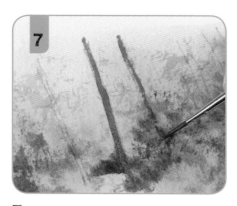

7 Use the size 2 round brush to paint in the midground trees using the grey-green mix (viridian and cobalt violet). Start from the bottom and work up each trunk in turn, breaking up the line near the bottom to suggest intervening foliage.

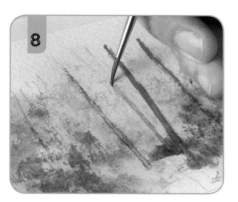

8 Dilute the mix to soften it, and paint in some more trees. Those painted with more dilute paint will appear more distant. The lighter tone creates the illusion of depth in the painting.

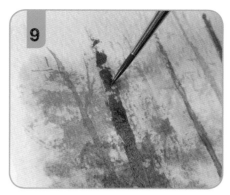

9 Similarly, strengthening the tone, by adding more paint, will allow you to paint trees that appear closer. These will be more convincing if you paint them a little larger than the midground trees and allow the drier paint to break up a little, as this will create the impression of more detail and intervening leaves.

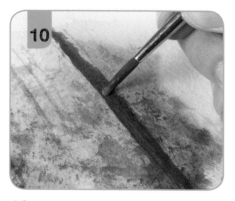

10 Brush some neat cerulean blue with the size 4 round into the darker, nearer trees to prevent them being too oppressive.

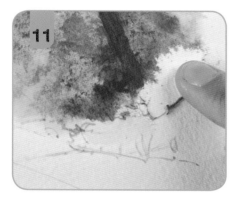

11 Once dry, carefully remove all of the masking fluid. Note how the effect differs between the hard line on the path, and the softer feathered lines on the foliage, where you used wetted masking fluid.

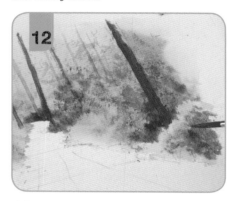

12 Build up the woodland floor on either side of the path using a variegated wash; exactly as for the background at the top – using the same mixes and brushes. Again, leave the dilute lemon yellow visible at the top, and restrict the darker tones towards the bottom of the picture. It is important not to work up to or over the light edge you masked out at the top, or the foreground and background will merge into one area.

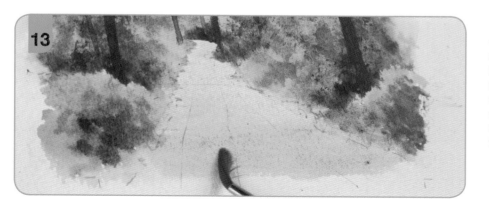

13 Use the size 6 brush to wet the path with clean water, then drop in a thin wash of raw sienna and burnt sienna, starting from the middle of the area. Allow the paint to work upwards, but don't encourage it too much – you want the distant path to be nearly white. Add more burnt sienna to the mix for the foreground area and work down to the bottom of the painting.

Technique: Using body colour

As mentioned earlier, most watercolours paints are transparent or translucent, meaning that some light will still reflect from the surface of the paper beneath them. This also means that colours applied earlier will show through beneath later layers, preventing you from painting light colours on top of dark ones. Body colours are opaque. They completely cover the surface, allowing no light through. They can thus be used to add bright highlights of particular colours on top of anything beneath, even dark colours. Using body colour is a great way to suggest foliage over dark trunks and branches, as in steps 14 and 15.

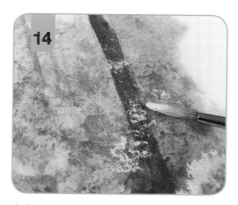

14 To create the sunlit leaves in front of the trunks and branches of the trees, we can use opaque paint. Use the dry brush technique to apply primrose yellow as before. The opaque nature means that it will cover even the dark tones of the tree.

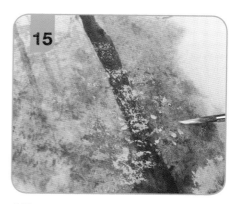

15 Add lemon yellow touches in the same way for variety. The dark tones may show through a little, giving a semi-transparent look and stopping the body colour appearing to sit on top, which can look artificial.

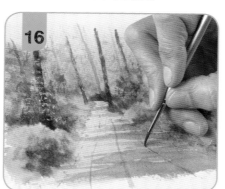

16 Make a purple mix from cobalt blue and cobalt violet. Make it very thin – almost transparent. Use the tip of the size 2 brush to draw fine lines across the distant path as shadows. Work the shadows over the foliage at the sides, as well. The shadows should get larger as you advance towards to the front of the painting, so switch to the size 6 brush. Add a few lines to the path that lead the eye into the painting with the dilute purple mix.

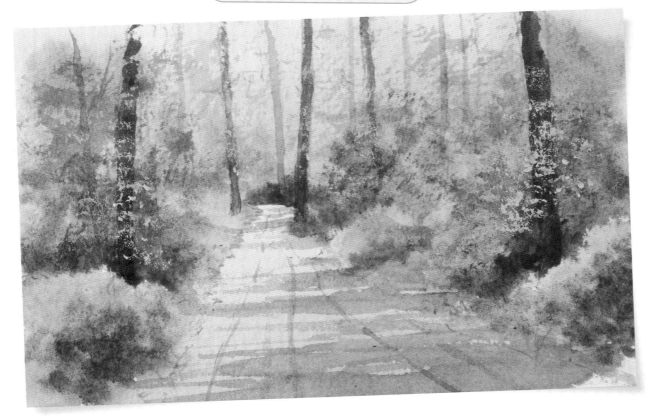

Summer trees

YOU WILL NEED

Paint colours: Naples yellow, cobalt violet, viridian, French ultramarine, burnt sienna, cobalt blue, rose madder, raw sienna, aureolin

Brushes: size 16 round, size 6 round, size 10 round, size 4 round, size 8 round, size 2 round

Other: putty eraser, tracing number 4

Sometimes it is impractical to paint a complex area wet-in-wet. You might have multiple layers to paint, or simply a lot to do. If you attempt to paint the whole area in one go, the effect when you start might be different from that at the end, as the paint has dried somewhat by the time you get to it. In order to resolve this, let the whole area dry, and then you can work on top again using techniques such as glazing and re-wetting, which are demonstrated here.

1 Prepare a thin wash of Naples yellow and cobalt violet; a dark green wash of viridian, French ultramarine and burnt sienna; a dilute purple mix of cobalt blue and rose madder; and a thin wash of raw sienna. Use the size 16 round to wet the sky. Working from the top of the paper down and over the tops of the mountains, create a subtle variegated wash by dropping in a little of the raw sienna wash and the purple mix over the tops of the hills with the size 6 round brush.

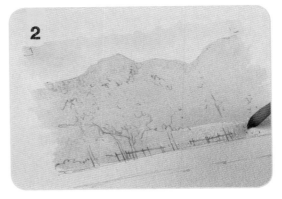

2 Once dry, take the size 10 round to paint the background hills with the mix of Naples yellow and cobalt violet. Work down to the foreground field, leaving a level line where the background meets the line of the field. Add a touch more cobalt violet lower down.

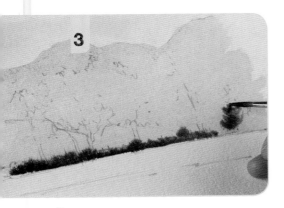

3 While still wet, change to the size 4 round and paint the hedgerow at the border of the field with the dark mix. Keep the bottom of the line level, but vary the top. You can suggest small trees simply by working up into the hillside.

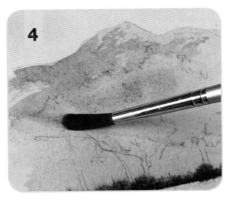

4 Apart from the very crest, the hill is in shadow. Use a thin wash of cobalt blue and rose madder to glaze over the top of the surface with the size 8 round. Note how the underlying colour affects the colour of the glazing paint on top. Keep in mind the direction of the light during this process.

Technique: **Glazing**

Glazing is the process of adding a layer of colour over the top of a dry area. Because watercolour is semi-transparent, it does not obscure the colour beneath, but instead enriches it as some of the underlying colour shows through the semi-transparent glaze. Glazes are applied just like washes; just make sure the area you are working on is dry before you start.

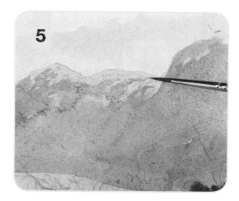

5 Use the size 2 to pick out some smaller touches near the crest, creating the impression of sunlight, shadows and texture.

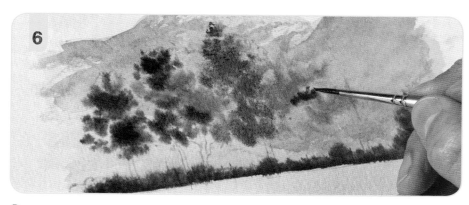

6 Prepare plenty of the dark green mix – viridian, French ultramarine and burnt sienna – at a thick, creamy consistency, then use a clean brush to re-wet a small section, on the left-hand side, of the dry surface of the hill. Use the size 2 brush to paint in the fir trees with light touches. Vary the mix with some of the light green mix of aureolin and cobalt blue; and raw sienna. Allow the area to dry, then repeat the process in an adjacent area. Continue until the whole area is complete.

Technique: **Re-wetting**

Re-wetting is a useful technique to use if you want a soft, slightly diffused finish to an area in front of a part that has already dried – as in the foliage in step 6. When re-wetting an area, work lightly to avoid disturbing the underlying colour, or the new colour will spread too far and you will end up with mud.

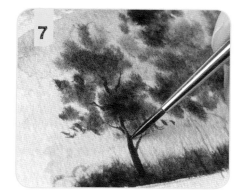

7 Once dry, you can add trunks to connect the foliage areas to the ground using the size 2 round and a dark mix of burnt sienna and French ultramarine. Do not simply paint straight lines up and through. Instead, vary the width of the lines, and break them up inside the foliage, to suggest that the leaves are in the way.

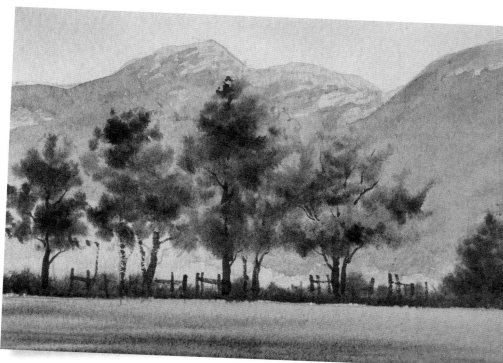

To finish, paint the foreground field with the light green mix and the size 6 round, then add some of the dark mix wet-in-wet at the bottom to frame the area.

8 Use the same mix and brush to add a few fenceposts. Do not worry about being too straight and tidy; these will be more convincing if they are slightly askew.

Bluebell wood

This project looks again at feathered masking, in which masking fluid is applied to a wet surface. This causes it to flow a little and allows you to avoid the hard edges typically associated with masking fluid.

Note that, despite the name, bluebells are commonly more violet than blue, so make sure to include a fair amount of the cobalt violet when preparing the paint mix for these beautiful flowers.

YOU WILL NEED

Paint colours: primrose yellow, aureolin, cobalt blue, viridian, French ultramarine, burnt sienna, cobalt violet, white gouache

Brushes: size 10 round, masking fluid brush, size 6 round, size 4 round

Other: masking fluid, bar of soap, tracing number 5

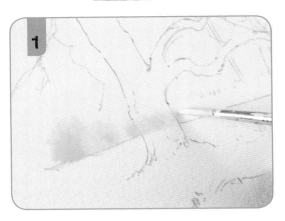

1 Wet the paper just above the bottom third of the painting, following the line on the tracing, using clean water and the size 10 round brush. Tip your board at an angle to prevent it running too far upwards, then add masking fluid above the line. This will bloom upwards to create soft foliage later. Allow to dry.

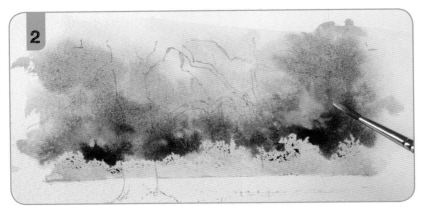

2 Prepare the following mixes: primrose yellow at a very thin consistency; a bright green mix of aureolin and cobalt blue; a blue-green mix of viridian and cobalt blue; and a dark green mix of viridian, French ultramarine and burnt sienna. Wet the whole background down to the masking fluid, then create a variegated wash using the size 10 round and primrose yellow; dropping in bright green and then blue green wet-in-wet. Switch to the size 6 brush and drop in areas of the dark green mix wet-in-wet, concentrating it immediately above the masking fluid.

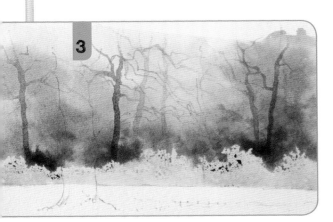

3 Pick up some thick primrose yellow from the palette well, then add it in at the top of the dark green areas. This will help blend the colours in the background together. Once dry, create a grey mix of cobalt blue, cobalt violet and burnt sienna and use the size 2 round brush to paint the background trees. Vary the consistency of the mix to create different tones.

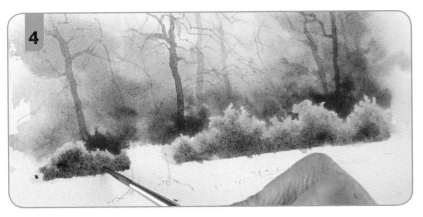

4 Once dry, remove the masking fluid with a clean finger to reveal a soft edge. Apply dilute primrose yellow to the revealed foliage shapes using a size 6 round brush, stopping at the edge of the big tree. Drop in the bright green, then the blue-green, then the dark green mixes wet-in-wet, covering increasingly less of the area and not allowing it to blot out the light at the top edges of the bushes. You may find it easier to swap to the size 4 for the dark green additions, as these cover very little of the area.

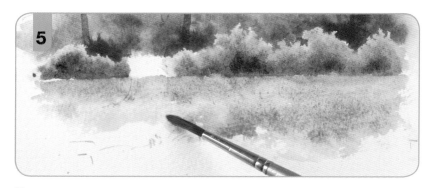

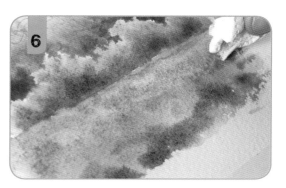

5 Make a bluebell mix from cobalt blue and cobalt violet. Using a size 6 brush, paint the foreground forest floor with the bluebell mix, working right the way across the big tree. Add some clean water here and there to keep the colours soft. You want to create the impression of a mass of bluebells in this area, not individual flowers. Add the bright green and blue-green mixes wet-in-wet at the bottom of the area.

6 Change to the size 4 round brush and add in stronger touches of the bluebell mix to enrich the colour near the foreground. Use the side of the size 4 brush to darken the foreground with the dark green mix. Lift out a few subtle areas from the bluebells using some clean kitchen paper.

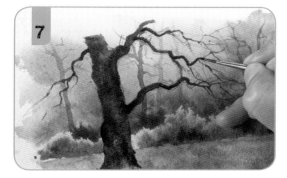

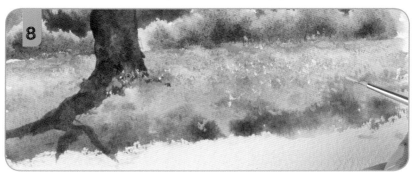

7 Once dry, drop in a mix of viridian and cobalt blue on the trunk of the big tree, then add a rich dark brown mix of French ultramarine and burnt sienna wet-in-wet. Add some branches with the same dark mix and the tip of the size 2 round brush.

8 Extend the dark green to the lower left to create a cast shadow. Brush some of the dark mix from the tree itself into the shadow to show that shadows are darkest nearest the object casting them. Mix cobalt blue and cobalt violet into white gouache to make an opaque bluebell colour. Apply this mix over the bluebells and the base of the tree with the size 2 round and the dry brush technique.

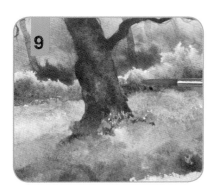

9 Wet the shadow of the tree with a clean damp brush, then add a little dilute lemon yellow to soften it into the undergrowth. Strengthen the dark green in the bushes next to the tree for added contrast.

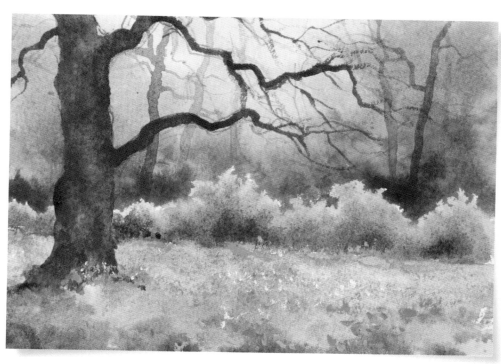

YOU WILL NEED

Paint colours: cobalt blue, French ultramarine, aureolin, lemon yellow, primrose yellow, raw sienna, burnt sienna, viridian, rose madder, cobalt violet, light red

Brushes: masking fluid brush, size 2 round, size 4 round, size 6 round, size 8 round, size 10 round, size 16 round

Other: masking fluid, tracing number 6

The changing seasons

Years ago, when I was learning watercolour – not that you ever stop learning – I used to enjoy taking a photograph of a scene, and then use my imagination to paint the same scene in different seasons. When I was planning the various projects for this book, it occurred to me that this might be of interest and inspiration to the reader, and I have to say I really enjoyed re-visiting this idea.

It isn't the best way to achieve accuracy, as you find yourself guessing to some extent what the scene might look like in a different season, but that is part of the fun. This is an exercise in using different colour palettes, and it really focuses your mind on the essentials of colour and tone. The small format of these pictures is ideal for this, and the time limit of half an hour helps to focus the mind.

My reference photograph was taken in May, when there was a rich carpet of bluebells on the ground, so it makes sense to start off with this spring version of the painting.

Given its similarity in atmosphere to the bluebell wood exercise on the previous pages, you can use many of the mixes and techniques from that exercise to help. For the bluebells in particular, I find a good colour mix is cobalt violet with cobalt blue.

Draw in the basic outlines before masking out the shape of the bridge with masking fluid. Use a thin wash of lemon yellow to paint the bright light in the centre, and frame it with richer,

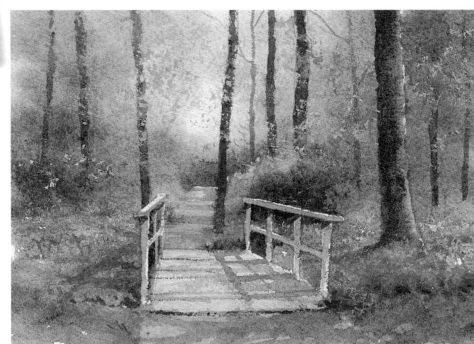

darker greens. Based on the colours in the photograph, I chose a blue/green made from viridian and cobalt violet; along with a darker green made from viridian French ultramarine and burnt sienna, placed behind the bridge on the left. The dark green serves to highlight the shape of the bridge structure, using counter-change (light against dark) for maximum contrast.

Use a thin wash of raw sienna to paint the bridge, taking care to stick to the shape you masked out without overlapping into the background. Once this has dried you can use a strong shadow mix made from cobalt blue, cobalt violet and burnt sienna to shade the upright timbers immediately under the hand-rail, using a number 4 round brush. The lighter shadows across the decking of the bridge were brushed in with a thinner wash of cobalt blue and rose madder, again using a number 4 round brush.

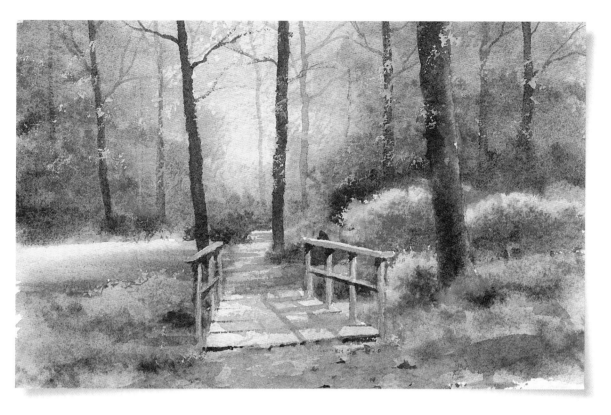

SUMMER

This summer painting uses very similar colours to the spring picture; but without the bluebells, and with more use made of the blue/green mixture of viridian and cobalt violet. The indications of brightly-lit foliage in front of the tree trunks and branches are put in with neat lemon yellow and neat primrose yellow, dry-brushed over the dry surface. For more information on painting a summer woodland scene see pages 26–27.

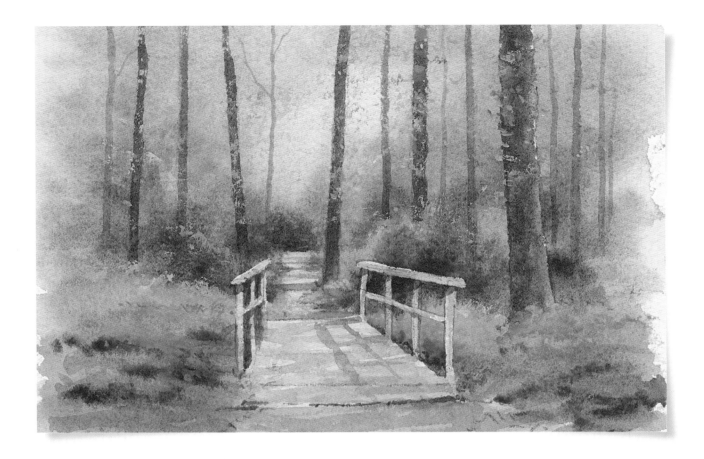

AUTUMN

This scene really lends itself to the warm, golden colours of autumn. I began, again with a thin wash of lemon yellow in the middle of the background, to give the scene a bright glow. While this was still wet I brushed in a mixture of aureolin and burnt sienna, plus a purple shade made from a mixture of cobalt blue and cobalt violet. This purple shade became a bit greyer as it mixed with the other colours. The large green bushes in the middle distance were put in with a dark green made from viridian, French ultramarine and burnt sienna; then for the highlights on the top of these bushes I mixed a touch of viridian with some primrose yellow.

For the suggestions of foliage in front of the trees and branches I mixed burnt sienna with lemon yellow, and dry-brushed it over the background once it had dried. For the shadows on the footbridge I used the same purple mix I had put in the background, made from cobalt blue and cobalt violet. For more information on painting an Autumn scene see pages 18–21.

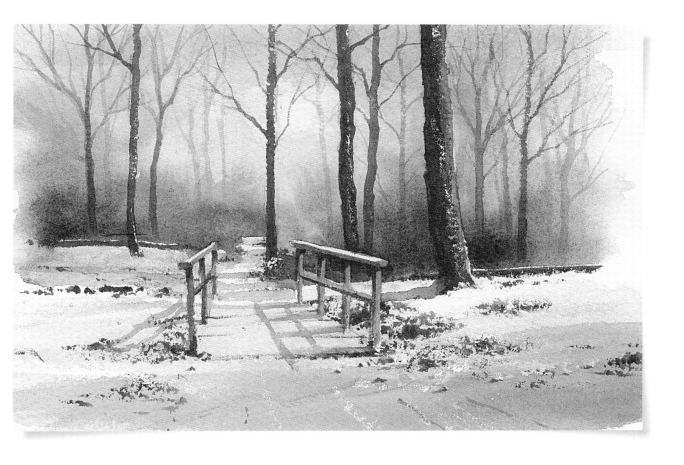

WINTER

It is rare for there to be snow on the ground when I am out and about during the winter, with one eye on the next potential painting subject. However, I do enjoy painting snow-scenes, and tend to look for any opportunity.

I used a hint of light red mixed with raw sienna to give that glow in the background, and cobalt blue for the top of the sky. The greys are made from cobalt blue, light red, and a touch of rose madder in various strengths, from the dilute washes in the sky and shadows, to the stronger mixes for the middle distance shapes.

The slightly warmer colour in the two widest tree trunks is mixed from raw sienna and burnt sienna, and this colour is also echoed in the timber on the bridge. The rich dark browns are made from a strong mixture of burnt sienna and French ultramarine.

For more information on painting snow scenes see pages 88–89.

TREES, TOWNS AND BUILDINGS

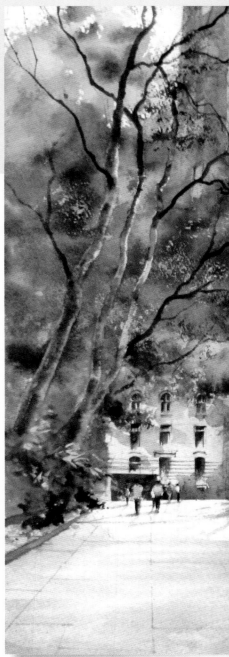

Trees often appear in the urban environment and offer a wonderful way to invigorate and lighten otherwise oppressive spaces in the urban landscape. Their colours and organic shapes give the artist the opportunity to soften and brighten the hard grey lines of towns and cities in their paintings. Even beyond habitations, trees work well alongside other forms of architecture, such as the bridge below. Here, they help to give a sense of scale to the otherwise anonymous structure.

The exercises in this part of the book look at how you can include trees in your townscapes and alongside buildings of various sorts.

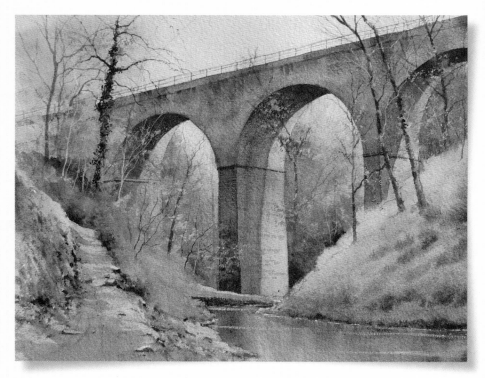

Viaduct in Millers Dale

53.5 x 35.5cm (21 x 14in)

While the bridge is definitely the focal point here, the softening effect of the trees and foliage are vital to the scene.

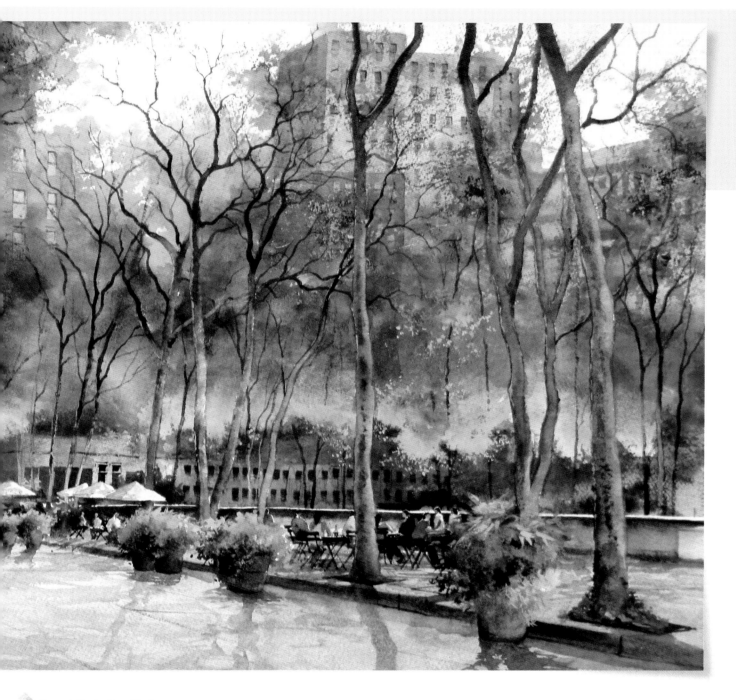

Bryant Park, New York

68.5 x 48cm (27 x 19in)

This painting makes the trees the star of the show. Even alongside the complex architecture, your eyes are drawn to the bright colours and fine detail in the tree. When adding fine branches like those shown here, look at your reference material to help you work out how many to add. As a general rule, do not add all the branches in your reference material; try to pick out just the most obvious ones instead – you are aiming to create an impression, not to produce a slavish copy of a photograph.

Farmhouse

YOU WILL NEED

Paint colours: aureolin, burnt sienna, cobalt blue, viridian, French ultramarine, burnt sienna, rose madder, lemon yellow

Brushes: masking fluid brush, size 16 brush, size 10 brush, size 2 brush, size 6 brush

Other: masking fluid, bar of soap, tracing number 7

There is no need to rush when painting this charming scene, particularly near the start. If you go in too quickly, the variegated wash will bleed too far, or the colours merge too much. The surface needs simply to be wet enough for the paint to flow a little. If you do find the paint running too far upwards into the sky, prop your board up at a slight angle until the surface dries a little. This exercise also introduces negative painting, a technique that involves painting the area around an object, rather than the object itself. This is a good way to ensure clean lines in your work.

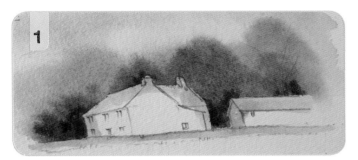

1 Mask the two buildings and the wall in front of them and allow to dry. Prepare the following mixes: an orange made from aureolin and burnt sienna at a fairly thick consistency, a little like full cream milk; a thin wash of cobalt blue; a brown made from burnt sienna and cobalt blue; and a green from viridian, French ultramarine and burnt sienna. Use the size 16 round to wet the sky with clean water, working around but not over the buildings. Change to the size 10 brush and paint the sky with the thin cobalt blue. While wet, float in the orange, brown and green mixes around the trees, concentrating the darker colours nearer the buildings. Allow to dry.

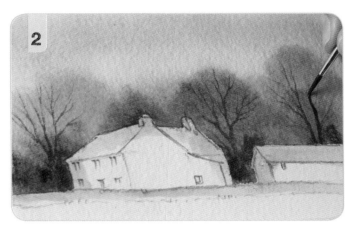

2 Paint in the trunks and main branches using the brown mix (burnt sienna and cobalt blue), applying the paint with the tip of the size 2 brush. As always, taper the branches outwards, but don't work right to the edge of the coloured foliage area.

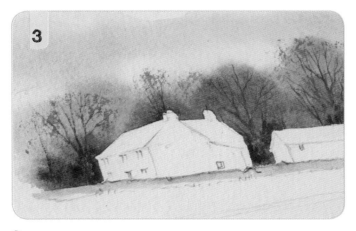

3 Make a thick opaque orange mix from lemon yellow and burnt sienna. Use the dry brush technique to add some detail to the foliage over the main branches. Allow to dry, then gently remove the masking fluid from the buildings only – leave it in place on the wall. If you accidentally rub a little of the wall masking away, you can reapply the masking fluid if you wish, or just work carefully around the area.

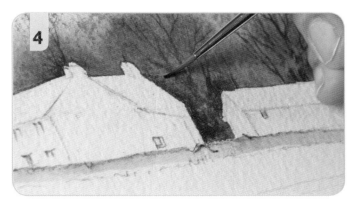

4 When you remove the masking fluid, you may find the line not quite straight, or not quite reaching the area that you wanted reserved. In these cases, use a fine brush to paint the background colour up to the edge, then soften it away into the background.

Technique: **Negative painting**

Step 4 is an example of negative painting. In short, instead of painting the shape itself, you paint the area up to and around it to leave a space in the correct shape.

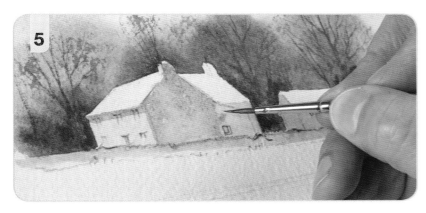

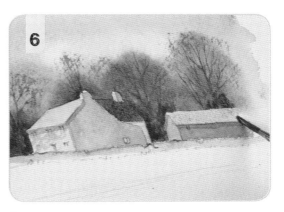

5 Use a very dilute mix of aureolin and burnt sienna to paint in the farmhouse on the left-hand side with the size 6 brush. Once this has dried, add more burnt sienna for a slightly darker variation and paint in the barn on the right-hand side. Leave the roofs clean, but paint right over the windows. Add some shadow to the buildings with a glaze of dilute cobalt blue. Pay attention to the light source (in this case, the light is coming from the top left) to help you work out where to place the shadows.

6 Change to the size 6 round. Add a touch of rose madder to burnt sienna and cobalt blue to make a deep, warm brown. Use this to paint the farmhouse roof in shadow, then paint the barn roof with dilute cobalt blue.

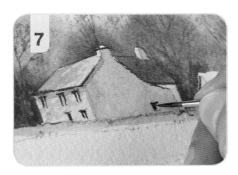

7 Add texture to the farmhouse roof with the same loose touches of dilute cobalt blue. Add more detail to the buildings with the very dark mix (French ultramarine and burnt sienna), picking out the edges of the roofs, deep shadows and windows with the very tip of the size 2 round.

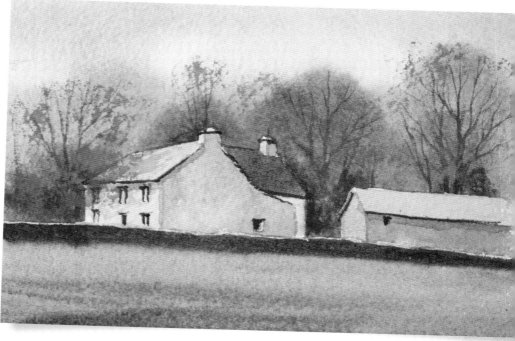

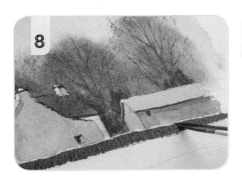

8 Use the dry brush technique to add foliage in front of the farmhouse with the opaque orange mix, then rub away the remaining masking fluid and paint the wall using the brown mix (burnt sienna and cobalt blue), leaving a white gap at the top.

To finish, add the bright green mix into the foreground field while the wall is still wet so that the two areas blend. Add aureolin, burnt sienna and the dark green mix to the field wet-in-wet for an autumnal feel, and paint the white gap at the top of the hedge using aureolin to prevent it being too stark.

YOU WILL NEED

Paint colours: raw sienna, burnt sienna, aureolin, cobalt blue, rose madder, viridian, French ultramarine

Brushes: masking fluid brush, size 16 round, size 10 round, size 4 round

Other: masking fluid, bar of soap, tracing number 8

Bandstand in the park

Trees are used in this exercise to draw the eye to the focal point of the park – the bandstand in the middle distance. They also act as a framing device, helping to create a relaxing, balanced image.

The foreground tree here is painted using a similar approach and techniques to the autumnal tree on pages 18–21 – once you've had a go, why not try repainting this scene in a different seasonal palette using the colours from another exercise?

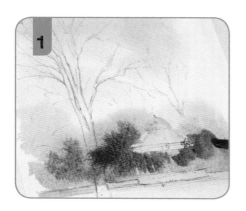

1 Mask out the bandstand and the hedgerow. Prepare the following mixes: raw sienna and burnt sienna; aureolin and cobalt blue; a grey made from cobalt blue, rose madder and touch of burnt sienna; a dark green from viridian, French ultramarine and burnt sienna. Wet the whole of the background down to the line of the hedgerow using clean water and the size 16 brush. Be careful to wet the area within the bandstand. Change to the size 10 round and paint the sky and background wet-in-wet, adding cobalt blue near the top and the mix of raw sienna and burnt sienna near the bottom. Drop in the dark grey mix near the bottom.

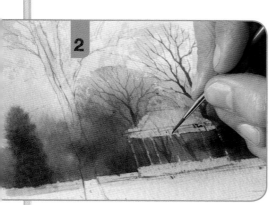

2 Suggest small trees with dark green touches behind the hedgerow using the size 4 round. Allow to dry, then use the tip of the size 2 brush to paint in the trunk and branches of the distant tree with the grey mix. Strengthen the mix with more paint and paint the midground tree in the same way. Note how the darker tone and size make it more eye-catching than the distant tree. Add some trunks visible through the bandstand with the same brush and mix.

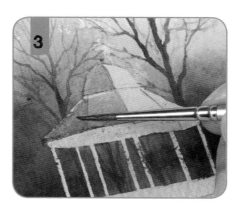

3 Once dry, remove all of the masking fluid with a clean finger. You may find that the masking fluid lifts off the pencil marks; you can re-establish these with a pencil if you wish. Paint the roof of the bandstand with the size 4 round and dilute cobalt blue. Allow to dry. The light is coming from the right-hand side, so add the shading on the left-hand side of the roof. Lay in a wash of cobalt blue over the areas, then touch in the grey mix wet-in-wet near the bottom of each panel in shade. You can make the leftmost areas still darker with a third layer; but do make sure the previous layer is dry first.

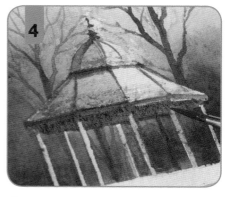

4 Use the tip of the size 2 brush to touch a little of the raw sienna and burnt sienna mix, and the brown mix (cobalt blue, rose madder and burnt sienna) onto the bandstand to make it appear lightly weathered. Mix viridian with cobalt blue and paint in the steelwork with this blue-green, then shade it with a glaze of the grey mix. Paint the underside of the roof with the same grey mix, touching in some of the raw sienna and burnt sienna mix for interest. Tint the uprights with cobalt blue. Once dry, use the tip of the size 2 brush to suggest a few posts at the back in shadow, using the brown mix.

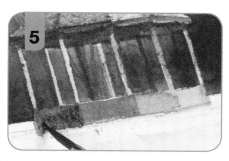

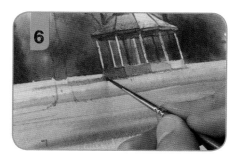

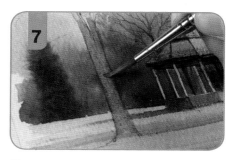

5 Paint the stonework pedestal on which the bandstand is built using raw sienna and burnt sienna, applying the paint with the size 4 brush. Allow it to dry, then glaze the left-hand side with the grey mix (cobalt blue, rose madder and a touch of burnt sienna). Repeat to build up a gradual sense of shadow and suggest the angular shape of the base.

6 Paint in the path using raw sienna and burnt sienna, adding shadow using the grey mix. Paint the grass using the aureolin and cobalt blue mix. Add shadows wet-in-wet on the grass with the dark green mix (viridian, French ultramarine and burnt sienna), and behind the bandstand with the grey mix.

7 Make three mixes: a light tone of Naples yellow and burnt sienna, a mid-grey mix of cobalt blue, rose madder and burnt sienna, and a dark brown mix of burnt sienna and French ultramarine. Using the size 4 brush, paint the trunk of the tree with the light-toned mix and allow to dry.

Technique: **Lifting out**

Lifting out involves gently re-wetting the paint to that you can soak it up with a piece of kitchen paper (or brush). This leaves a lighter area, making this technique very useful for creating highlights.

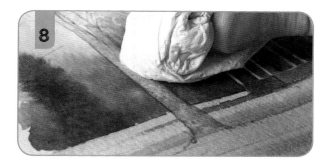

8 Gently agitate the paint on the large foreground tree with a damp brush, then press a clean piece of kitchen paper onto the area. This will lift away a little of the wet paint.

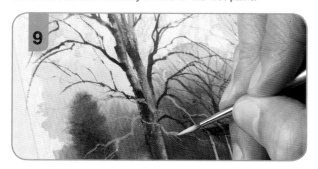

9 detail the foreground tree with touches of the mid-grey mix followed by the dark mix wet-in-wet, avoiding the right-hand side. Build up the main branches in the same way. Paying attention to how the branches arc away and downwards under their own weight, use the dark mix to paint finer branches, and pure Naples yellow for those in direct sunlight, using the same brush and technique. These are particularly effective in front of the darker areas of background.

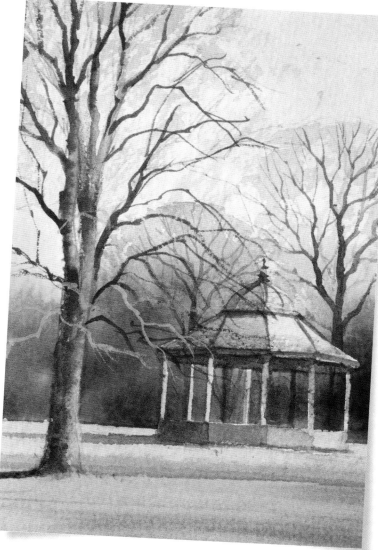

To finish, soften the base of the tree with clean water and dark brown, then paint the shadow cast by the tree using the size 2 brush and the dark green mix (viridian, French ultramarine and burnt sienna).

Paint colours: cobalt blue, rose madder, burnt sienna, cadmium yellow, French ultramarine, lemon yellow

Brushes: size 10 round, size 6 round, size 4 round, size 2 round

Other: tracing number 9

City trees

This more complex exercise does not introduce any new techniques, but instead is an opportunity for you to consolidate what you have learned so far. It is a great example of what you can achieve with watercolour. The tree here is the focus, but the hard lines and complex silhouette of the building behind provide an interesting counterpoint to the soft foliage.

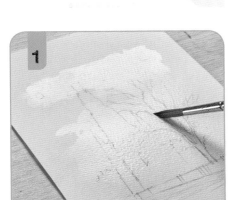

1 Prepare a well of dilute cobalt blue, then mix a grey from cobalt blue, rose madder and a little burnt sienna; plus a warm orange mix of cadmium yellow and burnt sienna. Use a size 10 to wet the sky area (including the tree and building). Leave a few streaks of dry paper at the top, and leave a gap behind the building.

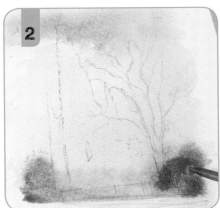

2 Starting from the top of the paper, drop in the dilute cobalt blue over the entire sky area, steering clear of the gap, and adding more pure water towards the bottom. Drop in the grey mix around the road to suggest the background buildings, then add touches of the orange mix wet-in-wet. Allow the painting to dry.

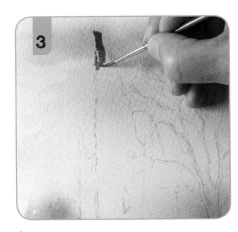

3 Prepare a thicker version of the grey mix (see step 1). Starting with the dilute grey mix, paint in the top of the main building using the size 2 round. Work wet on dry, with close reference to the original image. Treat the shape as a silhouette. This will simplify things and prevent the building becoming over-complex.

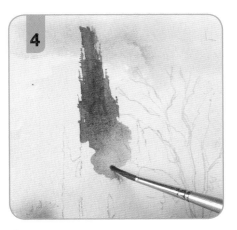

4 Change to the size 4 as you work down the building to allow you to work fairly rapidly – if you work too slowly, you will end up with a patchy result. Add some water near the tree, to dilute the grey behind the foliage.

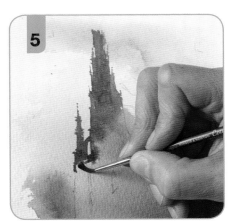

5 Introduce the stronger, darker grey mix towards the bottom of the building, and use the dilute, thin mix for areas behind the tree. Pay attention to the gaps near the bottom, but remember you are aiming to suggest the general sense of the building's shape, not for exacting architectural accuracy.

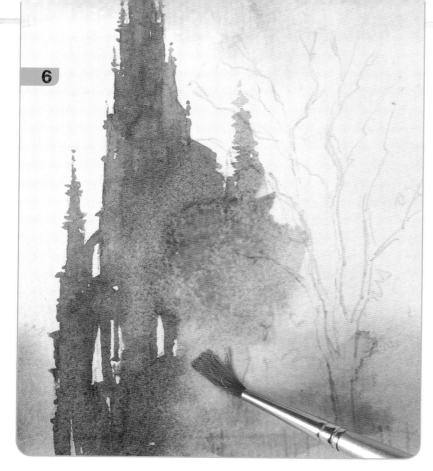

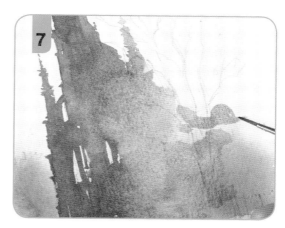

6 Introduce the warm orange mix wet-in-wet around the building using the size 6 round brush.

7 Use the size 2 round brush to develop the dome on the right with the grey mix. This will help to suggest the border of the tree.

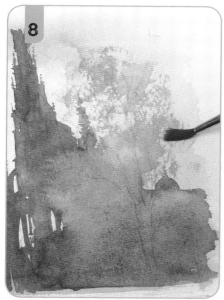

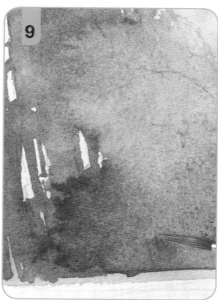

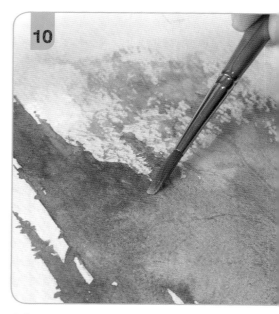

8 Swap back to the size 6 round brush and develop the foliage with more of the warm orange mix, working the paint into the wet paint of the bottom of the dome. Use the dry brush technique above the dome to create the impression of texture.

9 Warm the mix with burnt sienna and vary the foliage.

10 Pick out a few loose leaves in front of the building with some neat cadmium yellow added wet-in-wet to the dry-brushed foliage.

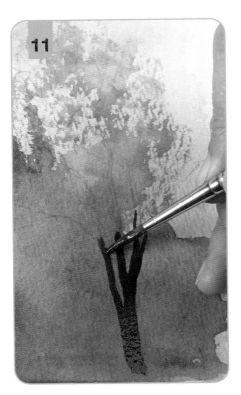

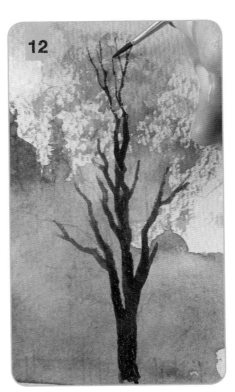

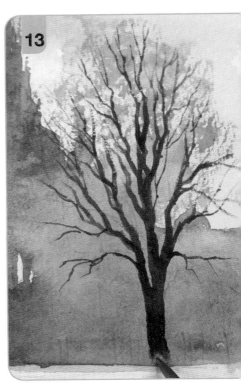

11 Make a dark brown from burnt sienna and French ultramarine and paint in the trunk of the tree with the size 4 round.

12 Work the tree upwards from the base, splitting it into the main branches. Change to the size 2 round brush for the finer branches, working up to, but not beyond, the edge of the foliage.

13 Once the fine branches are in place, soften the base of the tree into the ground with clean water.

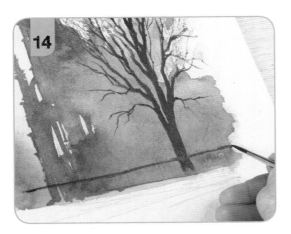

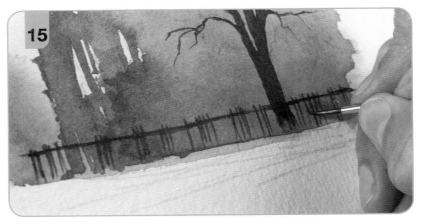

14 Paint the fence with the size 2 round and the same dark brown mix, starting with the top rail. Make the line quickly to help you get a straight line. Don't be tempted to use a ruler, as this can look artificial, and is liable to smudge as you lift the ruler away.

15 As you put in the individual posts, paint from the railing downwards, and work in clusters rather than simply from left to right. A few gaps create the impression of hedgerows growing through the fence.

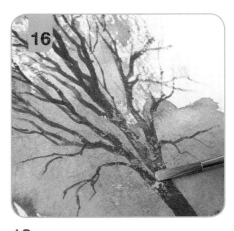

16 Use the size 4 brush and the dry brush technique to add pure cadmium yellow highlights across the tree. Repeat the process with a mix of lemon yellow and burnt sienna.

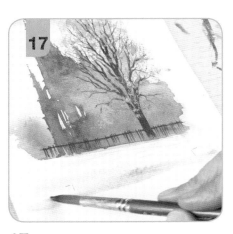

17 Wet the road with clean water, then drop in dilute cobalt blue mix with the size 10 round. Using some of the sky colour in the foreground helps to unify the image.

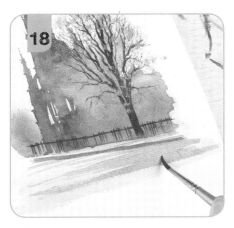

18 Once dry, suggest the edge of the kerb with the size 2 round and the stronger grey mix. Mix cobalt blue and rose madder for a shadow mix and bring the colour across the road with quick horizontal strokes, using the tip of the size 4 round brush.

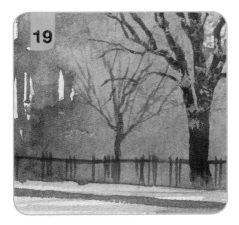

19 To finish, use the more dilute grey mix to add a distant tree near the centre of the painting with the size 2 round brush. This will lead the eye more towards the centre of the image.

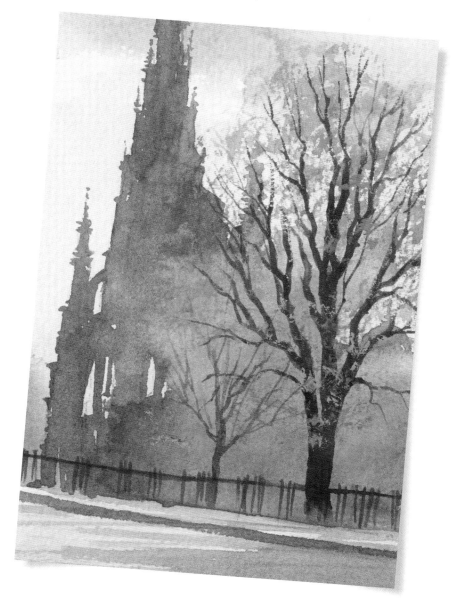

TREE VARIETIES

So far we have looked at trees in more general terms; this chapter looks at techniques and approaches for particular types of trees. It is true to say that most of the time I haven't a clue which particular species of trees I am including in the painting I am working on. Whilst some expertise on trees would be nice to have, as indeed most knowledge is better to have than not, I don't think it is important in terms of landscape painting – to be honest, I am too lazy to actually learn about them! I think it is more important to observe carefully whatever trees you are looking at, and make them look credible. However, in this chapter we will look at a few species that require specific techniques to render.

Old Ash Tree
46 x 30.5cm (18 x 12in)

This wizened old ash tree is in a woodland just beyond a place where we often stay in the Lake District; and one day I just got my watercolour block and paints and painted it on the spot.

I was intending to paint it as part of the woods, but I didn't do any drawing beforehand and ended up filling the paper with just one tree. Despite this, I enjoyed the painting process. I concentrated on making the branches look authentic as they dip down, due to their weight, the farther they get from the trunk. Despite the size of the tree, I have been careful to make the really small branches very fine by using a number 2 round brush with a really fine point.

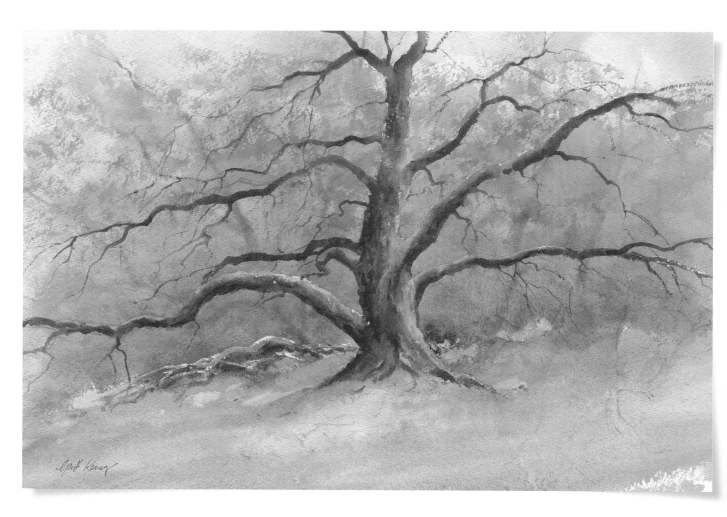

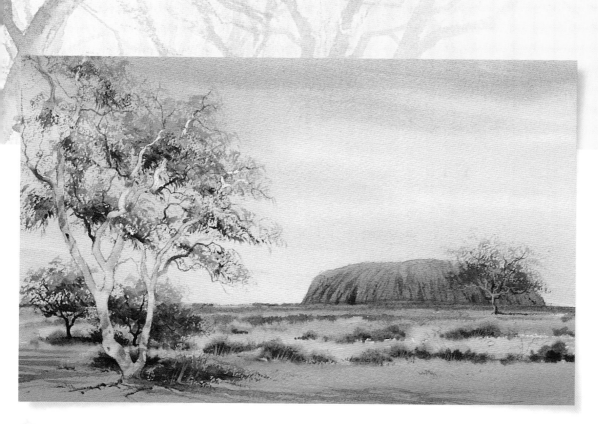

Ayer's Rock

51 x 33cm (20 x 13in)

I don't think you can actually get this view of Uluru (Ayer's Rock) with the mulga trees in this position, but they are certainly indigenous to this region, and I positioned them to enhance the composition. I masked out the fine trunk and branches of the foreground tree, before painting the foliage with dry brush work. Once the masking fluid had been removed, I painted the pinky colour onto the trunk and branches, then allowed it to dry before adding some blue shadows. Finally some darker small branches were added, to increase the effect of shadow, and make the tree appear more three-dimensional.

Cumbrian Farm

71 x 43cm (28 x 17in)

Try to imagine this painting without the fir trees, and I think you will agree that even though they partly obscure the farm buildings, the scene benefits immeasurably from their inclusion. I masked out the brighter parts of the trunks before painting the background hills and the farm – in fact, most of this picture was painted before the trees. I then re-wetted the background with clean water just behind the trees, taking care not to disturb any of the background colour, before floating a dark green mixture and some Naples yellow for the lighter parts of the foliage, onto the newly, re-wet background, to suggest the soft, shapes of the fir tree foliage.

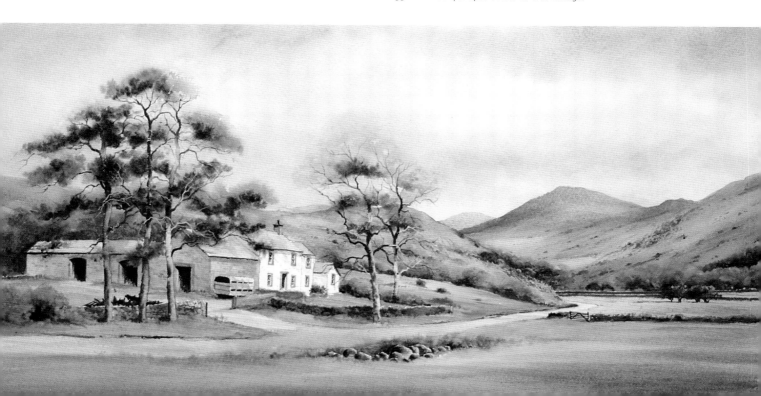

YOU WILL NEED

Paint colours: cerulean blue, cobalt blue, quinacridone gold, viridian, French ultramarine, burnt sienna, cobalt violet, lemon yellow, primrose yellow, raw sienna

Brushes: size 16 round, size 10 round, size 4 round, size 2 round

Other: tracing number 10

Oak

I was drawn to the rough texture on the bark and the seemingly haphazard angles of the branches sprouting from the wide, weathered trunk of this old oak. I also liked the lost and found effect caused by the patchy foliage.

1 Prepare a thin sky wash of cerulean blue and cobalt blue; an olive green mix of quinacridone gold and cobalt blue; a dark green mix of viridian, French ultramarine and burnt sienna; a grey-green mix of viridian and cobalt violet; a medium wash of lemon yellow; and a strong brown mix of raw sienna and burnt sienna. Wet the painting with clean water and the size 16 round, avoiding only the left-hand side of the oak's trunk. Change to a size 10 round and drop the blue wash into the sky, adding more water as you work down towards the ground.

2 Drop in the lemon yellow over the top of the oak's foliage, following by the olive green mix wet-in-wet. Change to a size 4 round and introduce the blue-green for further variety. Use a dappling motion to create texture.

3 Change down to a size 2 round and drop in the dark green nearer the central and lower parts of the foliage. While the paint remains wet, add some neat primrose yellow, then pick out a few dead leaves with the tip of the size 2 round brush and the strong brown mix.

4 Re-wet the area on the left-hand side of the tree trunk with the size 4 round and loosely suggest a bush behind the tree using the olive and dark green mixes.

5 Once dry, make a warm brown mix of quinacridone gold and burnt sienna, and a purple mix of cerulean blue and rose madder. Wet the trunk of the oak and float in some of the sky mix. Drop in the purple mix wet-in-wet, then the warm brown mix. Soften the colour away at the bottom.

6 Still using the size 4 round, drop in the strong brown (raw sienna and burnt sienna) wet-in-wet on the right-hand sides of the trunk. Suggest some of the texture and shaping on the gnarled bark with a variety of short angled strokes. Add the branches with the same strong brown mix, softening their bases into the foliage where they emerge with clean water and pure lemon yellow.

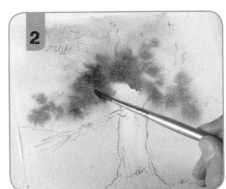

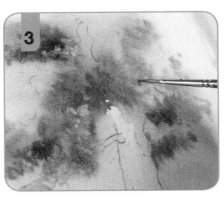

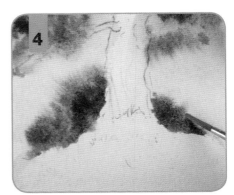

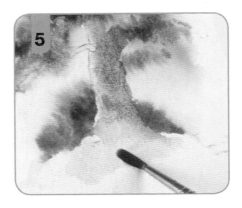

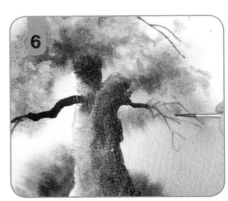

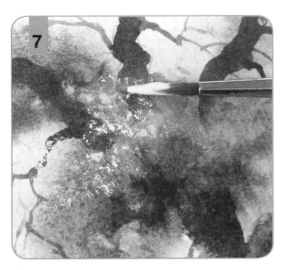

7 Using neat primrose yellow, begin to define the foliage with the dry brush technique and the size 4 round.

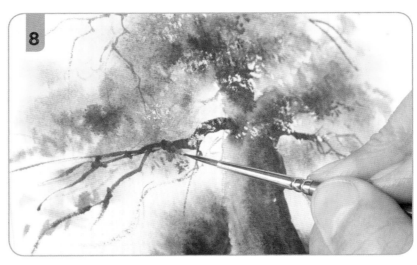

8 Switch to the size 2 round to pick out some tiny individual leaves with primrose yellow, then repeat the process with the dark green and the grey-green mixes. Use tiny movements of the brush to create dashes rather than dots.

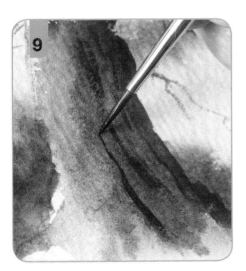

9 All that remains is to add a few finishing creases and crevices on the trunk using the dark mix and the tip of the size 2 round brush.

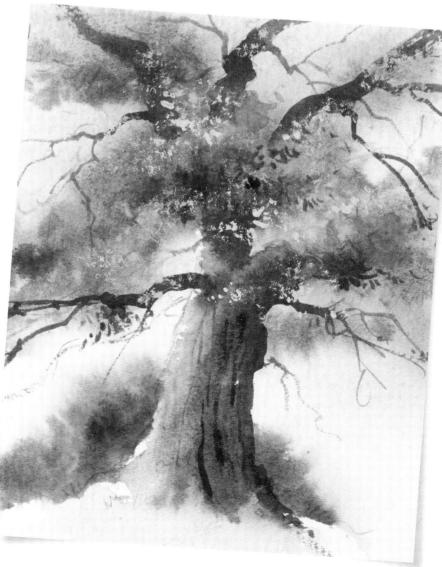

Paint colours: cerulean blue, cobalt blue, aureolin, lemon yellow, burnt sienna, French ultramarine, viridian, quinacridone gold

Brushes: masking fluid brush, size 16 round, size 10 round, size 2 round, size 4 round

Other: masking fluid, bar of soap, tracing number 11

Plane tree

The plane tree has a very distinctive texture, which we can replicate by gently agitating layers of masking fluid to gradually create an increasingly blistered surface, painting over it and allowing the colour to dry between each layer.

1 Apply the masking fluid to the trunk of the plane tree and allow to dry. Wet the surface with the size 16 round brush and clean water, then drop in a sky mix of cerulean blue and cobalt blue at the top with the size 10 round. Work this down, fading to pure water.

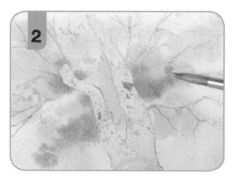

2 Still using the size 10 round, drop in a wash of lemon yellow wet-in-wet around the branches of the tree, followed by a bright green mix of aureolin and cobalt blue.

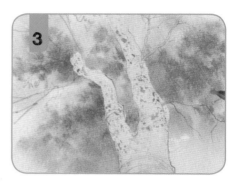

3 Darken the bright green mix on the palette by adding more cobalt blue and add small touches of this wet-in-wet to develop the foliage, avoiding the edges of the green area. Do the same with a copper-brown mix of quinacridone gold and burnt sienna.

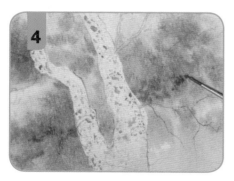

4 Change to the size 2 round and drop in a blue-green mix of viridian and cobalt blue here and there, concentrating around the central part of the tree.

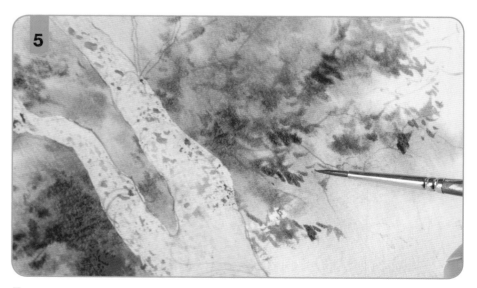

5 Knock back the blue-green by adding the copper-brown mix wet-in-wet. As these mix on the paper, you will end with a rich variety of hues. Use the size 2 with the foliage mixes to add the suggestion of a few individual leaves nearer the edge of the green background area. As you come to place these small marks, the paper should be starting to dry, which will help them keep their shape without being too stark. Combine the blue-green and copper-brown mixes on your palette to make an even richer dark for further variety. Allow to dry.

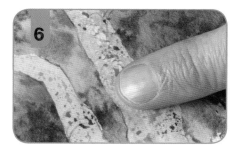

6 Use a clean finger to rub the masking fluid very, very gently – almost tentatively. This will open up random gaps in the masking fluid. Work slowly; you can always rub more away, but rubbing too hard will take off too much of the surface.

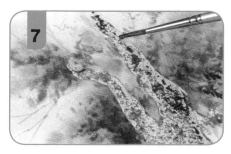

7 Thin the blue-green mix by adding more water and use the size 4 round brush to wash over the tree. Drop in the copper-brown mix and some of the dark mix here and there.

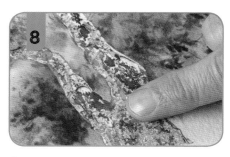

8 Allow the paint to dry, then gently remove a little more of the masking fluid as before.

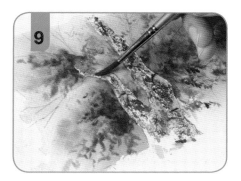

9 Add more of the copper-brown and blue-green mixes, concentrating the blue-green on the right-hand sides of the trunk and main branches to create shading. Reinforce the shadow with the dark mix (if you have run out, you can make some from burnt sienna and French ultramarine), added wet-in-wet.

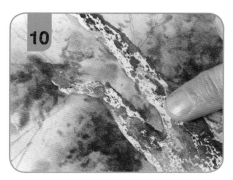

10 Allow to dry, then remove the remaining masking fluid to reveal the effect. This can now be refined with some further toning.

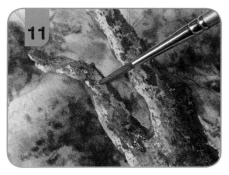

11 After running the green-blue mix down the right-hand sides of the trunk and main branches with a size 4 round, then soften the colour towards the centre with a clean damp brush. Add a little warmth by touching in some small marks of the copper-brown mix. Be careful to leave some clean white areas on the left-hand sides to represent sunlight and distinguish the tree from the foliage.

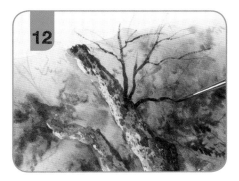

12 A few finishing touches can be added using a size 2 round; but you need do little more than reinforce the shadows and draw fine branches with the dark mix. Note that the fine branches come directly from the main branches and trunk on this tree; there are no medium-sized branches in between.

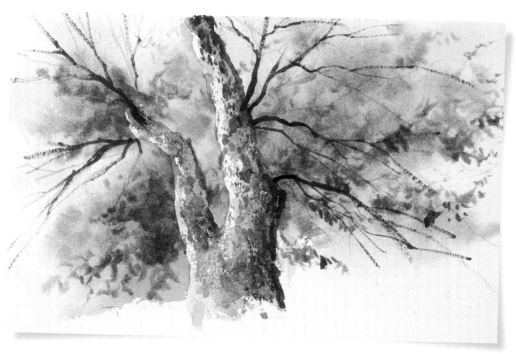

Weeping willow

YOU WILL NEED

Paint colours: cobalt blue, French ultramarine, burnt sienna, raw sienna, viridian, light red, cadmium yellow, Naples yellow

Brushes: masking fluid brush, size 16 round, size 10 round, size 4 round, size 2 round, 6mm (¼in) flat brush

Other: masking fluid, bar of soap, tracing number 12

Willows are attractive and distinctive riverside trees which can be painted with a few simple techniques. Since they are most commonly found near riverbanks, this exercise also includes a simple river, to introduce you to painting water.

1 Mask the distant bank, the two middle distant riverbanks, and the trunk of the willow. Use a size 16 round brush to wet the background down to the ground level, then change to a size 10 and drop in a sky blue mix of cobalt blue and French ultramarine, making the colour stronger towards the top and lighter towards the horizon.

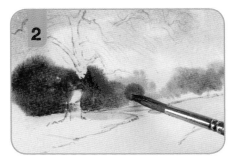

2 Drop in a warm orange mix of raw sienna and burnt sienna wet-in-wet with the size 4 round to suggest distant trees. Change to a thick nut brown mix of burnt sienna and cobalt blue, and apply it with the size 10 round brush all along the horizon, over and around the orange area.

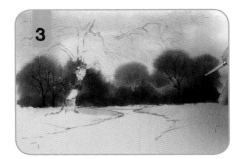

3 Strengthen the colour near the ground by adding more paint to the mix and touching it in wet-in-wet. Allow the paint to dry. Use a size 2 round brush to draw out the trunks and branches of the background trees with the nut brown mix.

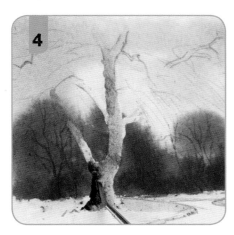

4 Remove the masking fluid from the tree. Prepare the following mixes: a blue-green of cobalt blue and viridian; a warm mix of light red and raw sienna; and a dark mix of burnt sienna and French ultramarine. Wet the tree with clean water using a size 4 round. Drop in the warm mix, then add the blue-green mix wet-in-wet. Add dark brown on the left of the tree with the size 2 round brush.

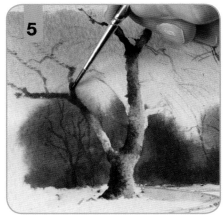

5 Use the same nut brown mix and size 2 brush to add the main branches. Perhaps contrary to expectations, these generally point upwards.

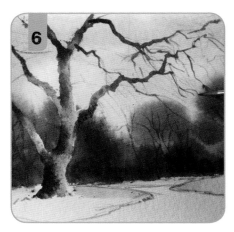

6 Once they are in place, begin to add the finer branches, which do droop downwards, using the same mix and the tip of the size 2 brush.

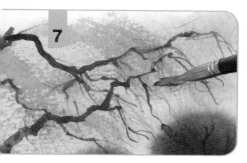

7 Prepare a mix of cadmium yellow and light red. Pick the colour up on the 6mm (¼in) flat and use sweeping, downward curving strokes to establish the fine twigs and leaves stemming from the fine branches.

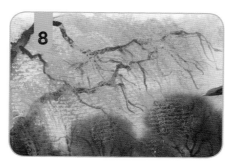

8 Still using the 6mm (¼in) flat, build the effect by applying pure Naples yellow in the same way. This technique will gradually obscure the underlying branches.

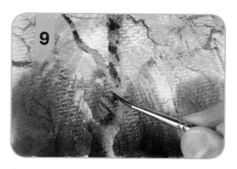

9 Using the dark mix (French ultramarine and burnt sienna), re-establish a few areas where the trunk and branches show through, using the size 2 round. This helps prevent the tree looking flat.

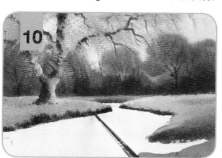

10 Once the tree is completed, you can remove the remaining masking fluid from the river banks and paint them using an olive green mix of cadmium yellow and cobalt blue; and a dark green mix of viridian, French ultramarine and burnt sienna.

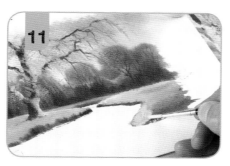

11 To paint the river, mask the river bank where it curves back in on itself.

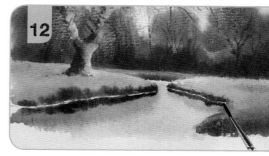

12 Once the masking is set, wet the river area with clean water and paint in the river water using the sky mix (cobalt blue and French ultramarine) and the size 4 round brush. Drop in bands of olive green (cadmium yellow and cobalt blue) and dark green (viridian, French ultramarine and burnt sienna) wet-in-wet.

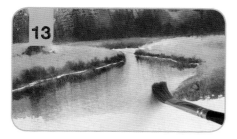

13 Make sure your 6mm (¼in) flat brush is clean and dry, and use it to lightly stroke the paint downwards to suggest the reflections. From here, finishing the painting is as simple as removing the masking fluid once the paint has dried.

If the masking takes a little of the paint with it, you can reapply the paint – this is much easier than not masking and having to clean up any vertical streaks from the flat brush.

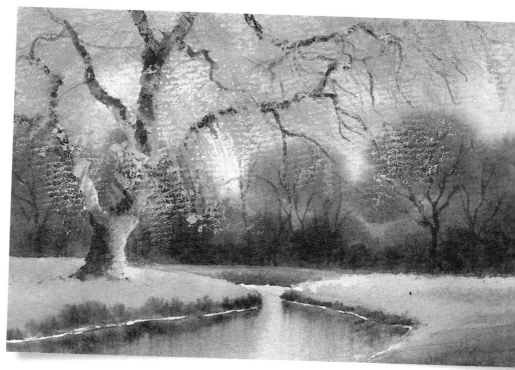

Paint colours: cobalt blue, light red, raw sienna, Naples yellow, burnt sienna, viridian, French ultramarine, lemon yellow

Brushes: masking fluid brush, size 10 round, size 4 round, size 2 round

Other: masking fluid, bar of soap, tracing number 13

Fir trees

In addition to learning how to paint pine trees, this exercise will show you how to use trees to frame the scene and lead the viewer's eye into the painting. When painting firs, keep any yellow touches sparing; fir trees are mainly cooler blue-greens, and too much yellow can make them look odd.

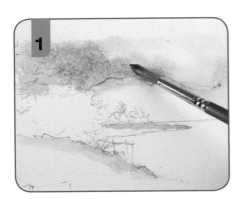

1 Mask out the crest of distant hills and the peninsula on the lake, plus the area under the trees. Wet the sky down to the hills with the size 10, then drop in cobalt blue. Working wet-in-wet, drop in a grey mix of cobalt blue and light red, particularly near the mountains.

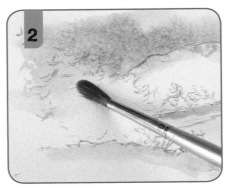

2 This dark mix will later contrast with the white snow-capped hills. Change to the size 4 round brush and soften the colour behind the fir tree with clean water; do not allow a hard line to form. While the paint dries, mix a bracken colour from Naples yellow and light red; and a dark brown from burnt sienna and cobalt blue.

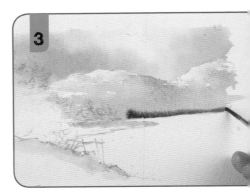

3 Once dry, remove the masking fluid from the hills with a clean finger. Using the dilute cobalt blue and the grey mix you used in the sky, add shadows to the hillsides, applying the paint and then drawing it out with a damp size 4 brush. Leave a few white patches for the snow, and keep the darker areas on the right-hand sides of the hills. As you work down, introduce the bracken colour (Naples yellow and light red), and then the dark brown towards the water's edge.

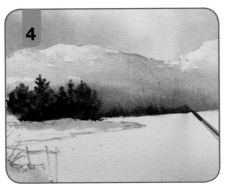

4 Working wet-in-wet with the brown mix, use tiny flicks of the size 2 round brush to introduce a mass of distant firs on the far side of the lake. Use a dark green mix of viridian, French ultramarine and burnt sienna to paint the firs, working each one down from their tips. Vary the size of the firs. Add more cobalt blue to the grey mix and touch this in on the water's edge to create a strong line.

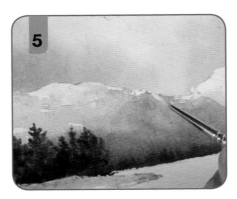

5 Once dry, use the original grey mix (cobalt blue and light red) to give more definition to one of the hills. This has the effect of knocking one back into the distance, and bringing the other in front. If required, use a size 2 round brush to add some white gouache to reinstate the snow on the ridge. Don't go overboard – a few touches are enough.

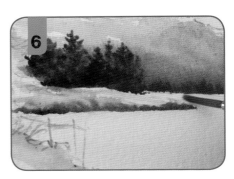

6 Once dry, remove the masking fluid from the peninsula. Add some cobalt blue over the area, leaving a line of white below the fir trees. Touch in the grey mix near the water's edge, then draw a line of a dark brown mix (burnt sienna and French ultramarine) across the edge while the grey remains wet.

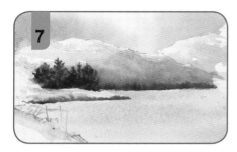

7 Change to the size 4 brush. Taking care to keep clear of the peninsula, and leaving a fine line of clean dry paper by the banks, fill the lake with clear water, then add a few streaks of the peachy mix. Add dilute cobalt blue wet-in-wet, starting from the far edge and working downwards.

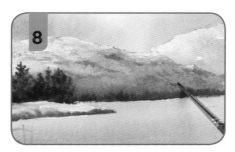

8 Add some of the grey mix at the very bottom, again using horizontal strokes. Once dry, add some texture on the closer hillside using the tip of the size 2 brush and the grey mix (cobalt blue and light red).

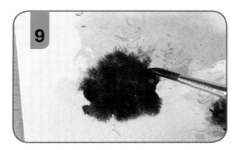

9 Change to a size 10 round and re-wet the fir tree on the left, taking the clean water beyond the edges of the tree itself. Working upwards from the bottom, apply the dark green mix (viridian, French ultramarine and burnt sienna) with the size 6 round brush, working up and outwards from the lower centre. Use slight taps to apply the paint, to give a dappled texture to the result.

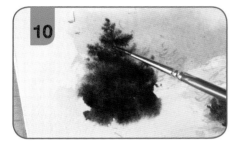

10 Change to the size 2 and add the top part of the main fir in the same way, using similar strokes, but smaller and more controlled. These foreground firs frame the picture, providing the eye with an anchor to lead the viewer into the scene.

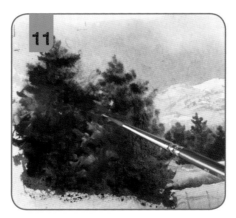

11 Build up the smaller fir tree in the foreground in a similar way. The wetness of the area is important – if it bleeds so much that you are losing the shape of the branches, it is too wet; pause and wait for the paper to dry a little before continuing. To distinguish the trees, add a few small neat lemon yellow touches with the tip of the size 2 brush to the left-hand sides as shown.

12 Once the trees have dried, you can remove the remaining masking fluid and paint the revealed corner with a cobalt blue and grey mix using the size 6 round. Details like the small wall in front of the foreground fir trees, a few scattered stones and the fencing to the right of the trees can be added with the dark brown mix and a fairly dry size 2 round. Leave thin white lines to suggest snow on top of these details, and remember the shadows cast by the fencing.

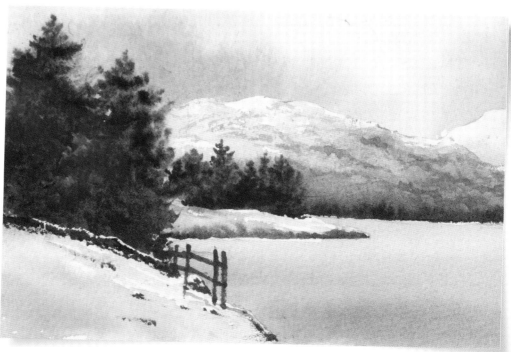

YOU WILL NEED

Paint colours: raw sienna, burnt sienna, aureolin, cobalt blue, viridian, French ultramarine, rose madder, primrose yellow

Brushes: masking fluid brush, size 16 round, size 10 round, size 2 round, size 6 round

Other: masking fluid, bar of soap, tracing number 14

Silver birch

The striking high-contrast bark of the silver birch tree can be replicated relatively easily used the masking technique alongside body colour.

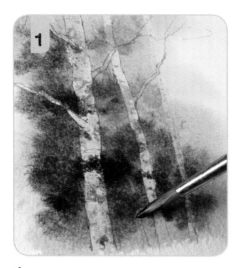

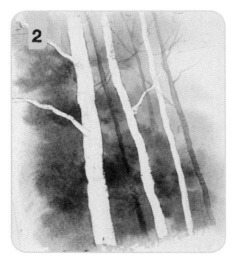

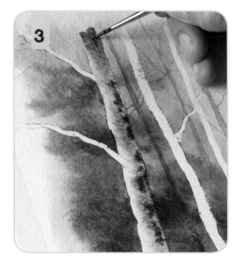

1 Mask the trunks and main branches of the three main trees. Prepare a warm mix of raw sienna and burnt sienna; a bright green from aureolin and cobalt blue; and a dark green from viridian, French ultramarine and burnt sienna. Once the masking is dry, wet the surface with clean water using the size 16 brush. Use a size 10 to lay in a variegated wash of the three mixes. Concentrate the greens around the centre and lower left and allow to dry.

2 Once dry, gently rub away the masking fluid using a clean finger. Make a medium grey from rose madder, cobalt blue and a little burnt sienna. Use this and a size 2 brush to suggest shadowy, more distant trees.

3 Mix cobalt blue with rose madder for a dilute purple mix. Make a light green mix from aureolin and cobalt blue, and a dark mix from burnt sienna and French ultramarine. Wet the largest birch trunk with clean water and the size 6 brush. Float in the purple mix, concentrating it on the right-hand side, leaving the left-hand side clean. Drop in touches of the light green mix wet-in-wet, then change to the size 2 brush and touch in a few blotches with the dark mix, again concentrating them on the right-hand side and avoiding the left-hand side.

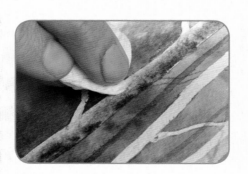

Tip

If too much paint bleeds over to the left-hand side, you can use a piece of clean kitchen paper to gently lift away the excess wet paint.

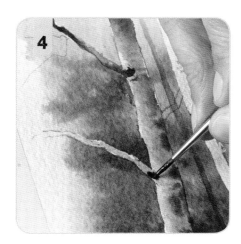

4 Use the same colours and techniques to paint the main branches, using the size 2 brush throughout. Keep the darker areas towards the bottom right of the branches, and use the dark mix as the main branch splits into very fine divisions.

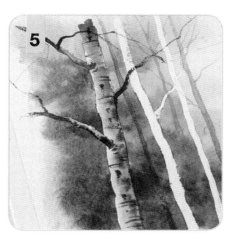

5 Using the same dark mix and size 2 brush, add a few knotholes and some fine broken horizontal strokes to suggest the distinctive texture of the silver birch bark. Next, paint the large branch which overlaps the next tree using just the dark mix, then allow to dry.

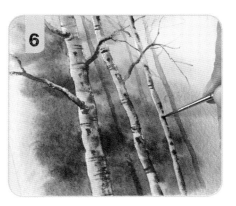

6 Wet the whole trunk of the central silver birch using the size 6 brush, and lay in the mixes in the same way as for the large left-hand tree, leaving the left-hand side light and concentrating the darks on the right. As before, add branches and fine details once the paint has dried. Finally, paint the third tree in the same way. This slim tree is more difficult to paint as it is harder to control the paint and keep the light and dark areas coherent – hence why we've tackled it last. The others will give you valuable practice.

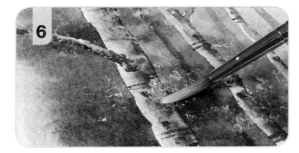

7 Use the dry brush technique with lemon yellow and a size 6 brush to add the suggestion of foliage in direct sunlight. Repeat the process with primrose yellow to reinforce and add depth to the effect.

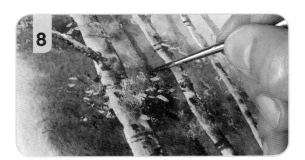

8 You can add some larger individual leaves with primrose and lemon yellow. Do not add too many, nor make them too large – using a size 2 brush will help with this. Finally, add in some darker contrasting leaves in the same way using the dark green mix of viridian, French ultramarine and burnt sienna.

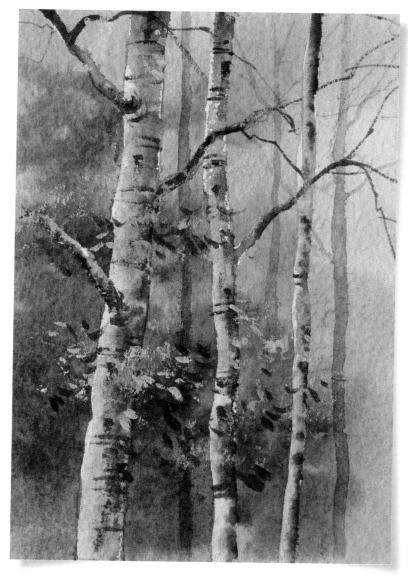

Paint colours: cobalt blue, French ultramarine, Naples yellow, light red, burnt sienna, aureolin

Brushes: masking fluid brush, size 16 round, size 10 round, size 2 round

Other: masking fluid, bar of soap, craft knife, tracing number 15

Saplings

The thin trunks and fine branches of young trees can be difficult to portray at the best of times, and when you need them to show up against both a dark background and a light sky, you need to know how to make them stand out. This exercise uses the useful 'scratching out' technique to reinstate light areas on dark paint.

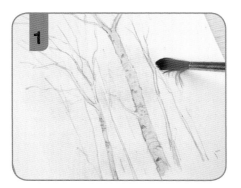

1 Mask out the main trees and one or two of the finer background trees. Once dry, wet the whole surface using the size 16 round brush and clean water. Change to the size 10 round and add a warm peach mix of Naples yellow and light red around the bottom half of the painting.

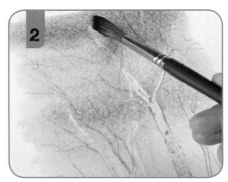

2 Rinse your brush and add a rich blue mix of cobalt blue and French ultramarine at the top of the painting, working down into the peach.

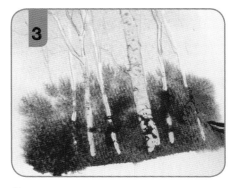

3 Drop in a slightly thicker nut brown mix made from burnt sienna and cobalt blue at the bottom to suggest the distant trees. Apply the paint with dabbing marks, and make the colour more dense at the bottom. If the paint starts to run too far up into the peach area, tip your board.

Technique: **Scratching out**

This technique relies heavily on timing. Get yourself ready, with the craft knife (or a cocktail stick) to hand, and watch the paint. While wet, the paint will appear reflective and glossy. You need to wait for the paint to lose its gloss, but not to have dried completely. If you work while the paint is too wet, the paint will simply flow back into the scratched-out line.

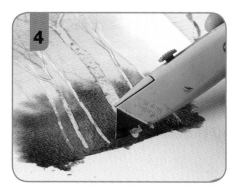

4 Once the paint has lost its gloss, place the point of the craft knife on the paper. Angle the knife so more of the flat of the blade is on the surface.

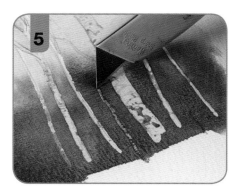

5 Draw the knife away sideways from you – this will ensure you drag the paint, rather than cut the surface to push the paint aside and leave a clean area of paper. Reduce the pressure to create a tapering line.

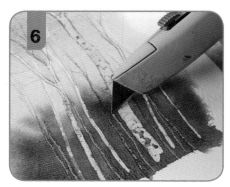

6 Repeat to create the impression of a few background birches. Note how the paint moved aside from the dark area is deposited at the end of the line, helping to create an unbroken impression of a tree trunk.

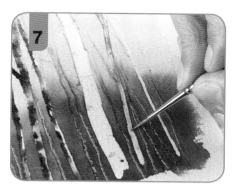

7 Remove the masking fluid. Mix aureolin and cobalt blue to make a green mix, and burnt sienna and French ultramarine to make a dark mix. Use the size 2 round to begin to paint the midground trees. Wet each tree in turn and drop in the peach mix unevenly on each trunk.

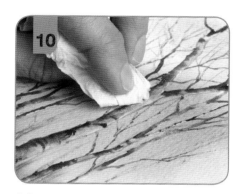

10 Once dry, use the size 2 round to add a few flicks and marks to represent the dark areas of bark and knotholes. Allow to dry, then use a clean damp brush to wet areas on the right-hand side of the main tree and lift away some paint with the kitchen paper.

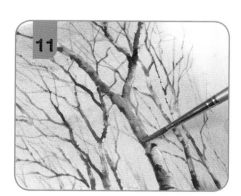

11 Warm areas of the main tree with glazes of a thin raw sienna and burnt sienna mix to strengthen the foreground tree, and make it appear nearer.

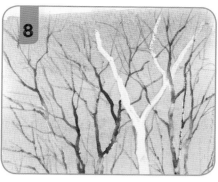

8 Touch in the green and dark mixes wet-in-wet. Use the dark mix for most of the finer branches, but combine the green and dark mixes for a few of them – this prevents all of the branches appearing the same. When painting the fine branches, make sure your brush is not overloaded and work relatively quickly; you do not want your branches to look laboured.

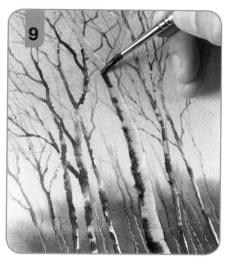

9 For the foreground tree, use the same techniques, but substitute the size 2 round for a size 4 round. Wet the tree with clean water, add peach wet-into-wet, followed by green, followed by a little of the sky blue mix, and finally the dark mix.

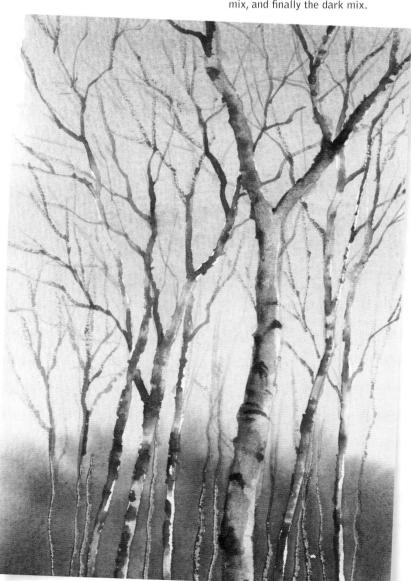

YOU WILL NEED

Paint colours: cerulean blue, cobalt blue, aureolin, opera rose, cobalt violet, white gouache, burnt sienna, French ultramarine, rose madder, lemon yellow

Brushes: size 16 round, size 10 round, size 6 round, size 4 round, size 8 round, size 2 round

Other: tracing number 16

Cherry blossom

In this exercise, you are not aiming to paint individual flower heads, but instead to create the impression of a mass of blossom. Swift but controlled wet-in-wet work is the key to success here. Preparing the paints in advance is a good idea, so read all the way through the instructions and make your mixes before starting the exercise.

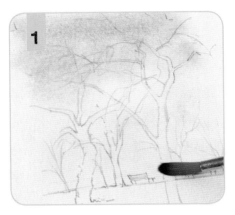

1 Start by wetting the top two thirds of the painting with clean water, using the size 16 round brush. Drop in a sky wash of cerulean blue mixed with a little cobalt blue using the size 10, working down from the top. Weaken the colour with more water towards the bottom of the wet area.

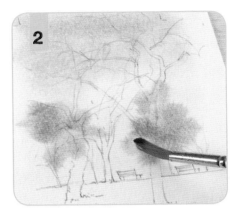

2 Make a green mix of aureolin and cobalt blue – this is slightly thicker and has relatively more blue than the other green mixes in the book – and drop it in wet-in-wet.

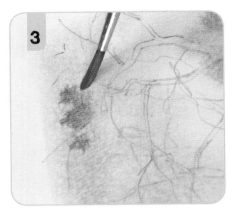

3 Change to a size 6 round and drop small touches of opera rose into the wet paint near the top of the main tree.

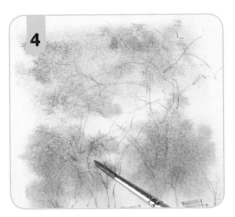

4 Continue adding more opera rose as you work down the tree, including into the green areas.

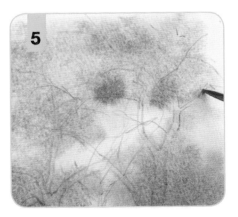

5 Drop in touches of a purple mix of cobalt violet with cobalt blue wet-in-wet, to create variety and interest.

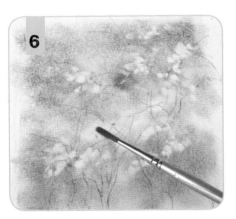

6 Working rapidly, change to a size 4 round and pick up some pure white gouache. Use the tip of the brush to add tiny touches in and amongst the pink and purple.

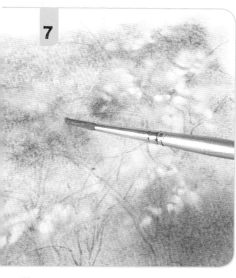

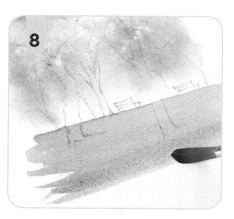

8 Using a size 10 round brush, bring the green mix across the middle distance. Work right over the trees, and introduce some of the purple mix right at the bottom of the picture.

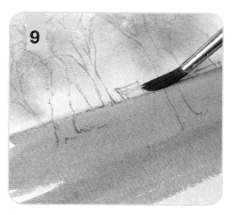

9 Once dry, run a damp size 8 back and forth along the horizon to soften the edge. Be sure to retain a little of the bright area between the ground and the blossom.

7 If any of the opera rose area needs muting, to calm the effect a little, add a hint of the sky mix wet-in-wet. Soften any over-strong white areas with more of the purple mix. Allow to dry.

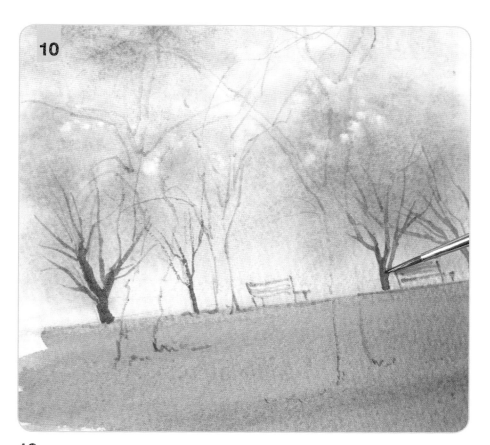

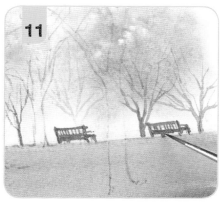

11 Paint the park benches with the same mix and brush.

10 Change to the size 2 round brush and use a grey mix of cobalt blue, cobalt violet and burnt sienna to paint the background trees. You can experiment with different tones for the trees; just remember that more distant trees will be paler in tone and appear smaller than those in the middle distance.

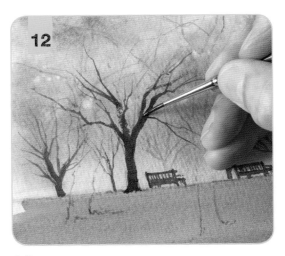

12 Still using the size 2 round brush, strengthen the grey mix (cobalt blue, cobalt violet and burnt sienna) by adding more of each colour to the well, then begin to paint the foreground cherry trees, using this stronger tone. Start with the most distant and work forwards.

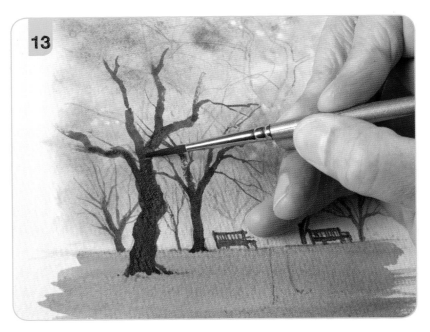

13 For the foreground cherry trees, change to a mix of burnt sienna and French ultramarine with a touch of rose madder. Use a size 4 round brush pay more attention to the gnarled shapes of the trunk and the angles of the main branches. Swap back to the size 2 brush to add finer branches which taper away to nothing in the mass of blossom.

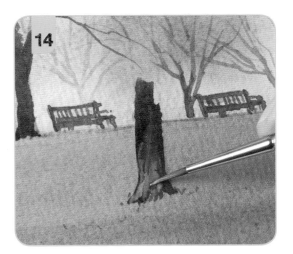

14 Build up the foremost tree in the same way, adding a little neat lemon yellow wet-in-wet at the base of the trunk.

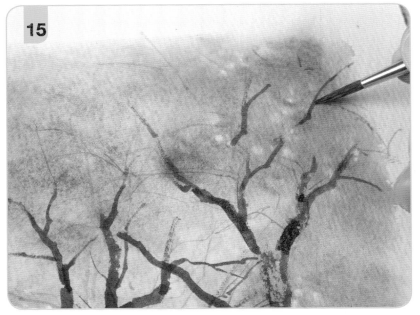

15 Break up the main branches a little, so they appear partly obscured by the blossom, by using a slightly dryer brush to draw the lines.

16 Change to the size 2 round brush to soften the bases of the trees, and add some subtle cast shadows using the sky mix.

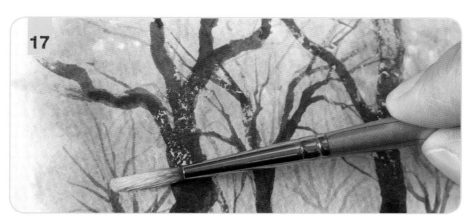

17 Change to the size 4 round and add a tiny amount of cobalt violet to opaque white. Use the dry brush technique to apply it to the foreground tree. Add opera rose to the mix for variety.

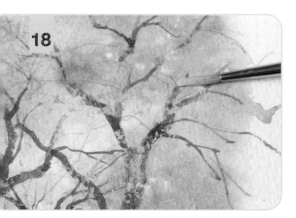

18 Continue building up the blossom using the opaque mixes, then add some of the purple mix (cobalt violet and cobalt blue) in the same way, to create a shaded area.

19 Finally, add some marks sparingly across the foreground grass. Step away for a few minutes before returning to the painting with fresh eyes. You may feel that you want to add some additional blossom on the tree or on the grass beneath it.

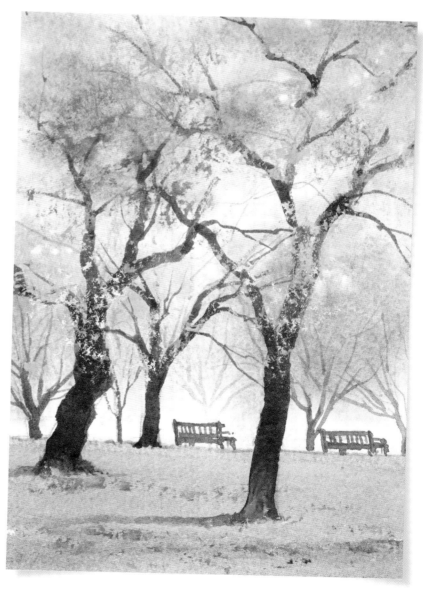

LIGHT, MOOD AND ATMOSPHERE

When I am out and about, I try always to have my camera with me; especially if I am walking. This can be just around where we live, on holiday or even working abroad – you never know when you will come across the subject for your next painting. All the scenes in this chapter were painted from photographs I took on just such occasions, coming across a scene when I least expected to. Nowadays, I don't even have to remember my camera, as I am never without my smartphone.

I particularly like the light early in the morning, when there is often a drifting mist or low cloud that gives the middle distance and distance an air of mystery. This works especially well for woodland near lakes, streams or rivers, and an early morning walk looking for this type of subject can pay dividends, whatever the time of year.

Another good time of day to seek out painting subjects is late afternoon. This time of day can provide some beautifully atmospheric subjects, particularly in the autumn when the warm colours and low contrast create marvellous mood and atmosphere. I find this a particularly good time of day to work into the light (a compositional technique called *contre-jour*), where the low contrast colours can suddenly be broken by a splash of bright sunlight catching a rooftop, the head of a walker, or similar detail. You can see an example of this in *Elterwater in Autumn*, the painting on pages 6 and 7.

The Old Railway Track, Darley Dale

10 x 20.5cm (4 x 8in)

We live very near to an old disused railway track, which my wife and I walk along several times a week, even in winter. This painting was inspired by a photograph I took early on a cold February morning. I have tried to convey the impression of the sun trying to break through the early morning mist.

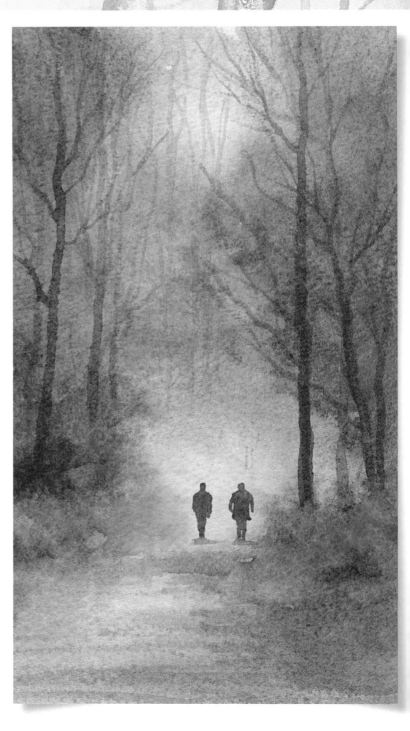

Winter's Afternoon, Chatsworth

71 x 48cm (28 x 19in)

Looking into the milky afternoon sun reduces the tree shapes virtually to silhouettes, and allows the use of a very limited palette of colours. I was particularly pleased with the impression of the glow from the sun itself, just left of centre. To achieve this I used the cap of a felt-tip pen to print a small circle of masking fluid (you can use any solid round object to print a similar circle), then painted the whole scene. Once the painting was complete and dry, I removed the masking fluid and used a damp clean brush to wear away the paint around the circle, at the same time fading the trunk and branches around the circle.

It is worth noting how the converging shadows from the trees enhance the perspective, and the two figures give us a sense of scale.

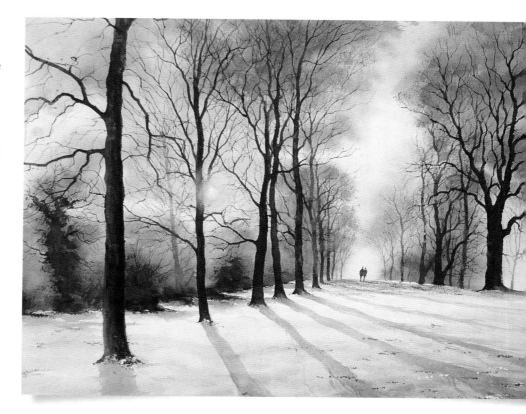

Lathkildale

40.5 x 40.5cm (16 x 16in)

This relatively simple scene is more about light than anything else. We are working *contre-jour* – looking into the sun – I like the way the bright afternoon sun is filtered through the trees. I deliberately put extra red into the tree trunks (burnt sienna) to add warmth, which I think contributes to the overall warm glow of the scene.

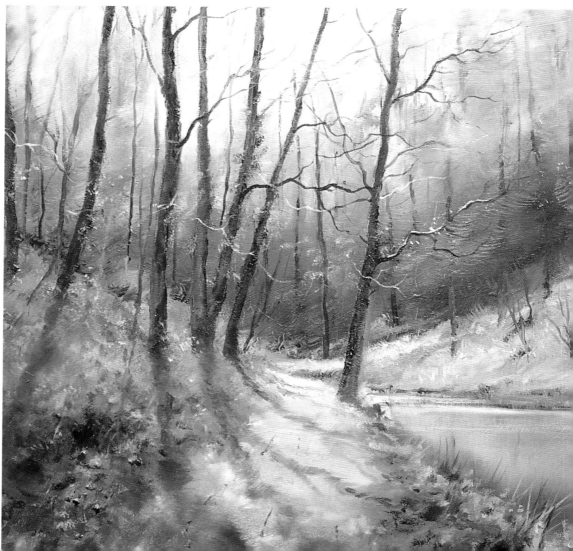

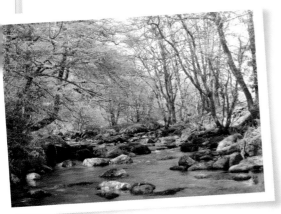

Warm and cool

In a similar way to the exercise on pages 30–33, here we use the same source photograph to make contrasting paintings, one on warm-tinted paper, one on cool-tinted paper. The results demonstrate how the use of tinted paper can help to alter the atmosphere, and strengthen the impression you want the viewer to have.

A tinted surface makes one paint in a different way, because the background colour of the paper – usually white – is no longer the lightest value in the scene. When using tinted paper, I therefore often add highlights with white gouache, in the later stages of the painting. The effect is particularly useful when, as in the example of the facing page, you are painting a snow scene. The cool colour of the tinted paper lends the painting a real wintery, late afternoon look, with the opaque white used to create clean, bright highlights.

Obviously the use of pure white gouache would not work as well on the summer version of the same scene (below) but it is useful to mix with watercolour to give it an opaque colour which can then be used sparingly to add detail in the same way. You can see this on the painting below along the top of the grassy bank in the centre.

YOU WILL NEED

Paint colours: cobalt blue, rose madder, French ultramarine, burnt sienna, raw sienna, white gouache

Brushes: size 2 round, size 4 round, size 6 round, size 8 round, size 10 round size, 16 round

Other: eggshell-tinted paper, tracing number 17

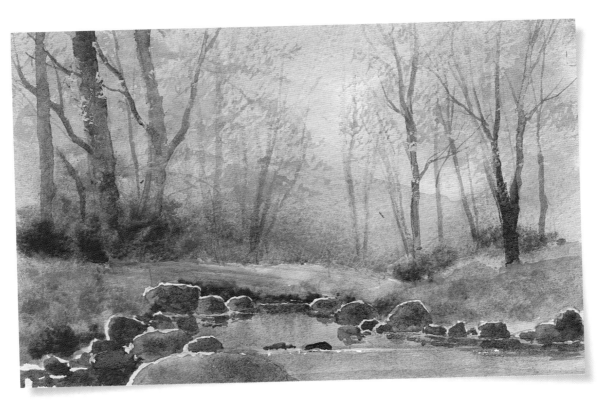

The warmth of the summer version of the scene is strengthened, and it immediately feels very inviting. Note that the highlights on the rocks (reserved using masking fluid) do not appear starkly white, because of the colour of the underlying paper. Use the colours listed above with the techniques on pages 22–25 to help you work through this painting using eggshell tinted paper.

YOU WILL NEED

Paint colours: cobalt blue, French ultramarine, Naples yellow, light red, burnt sienna, aureolin, white gouache

Brushes: size 16 round, size 10 round, size 2 round

Other: blue tinted-paper, tracing number 18

The second part of this exercise is to paint a wintry version on a cool, blue-tinted paper using the colours listed above and the techniques you have learnt so far.

Note how the blue colour seems to infuse a colder atmosphere. In order to prevent it appearing uninviting, raw sienna is used in the centre to warm and counteract the effect, giving an attractive result. You can see the effect of the white gouache on the top edge of the riverbanks in the middle distance as well as to create the effect of a light dusting of snow on the rocks and stones, the large green bush, and the bark of the trees.

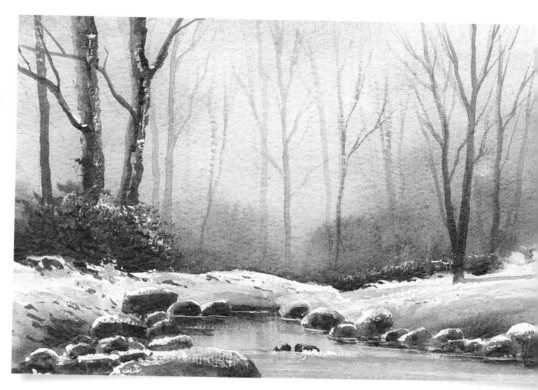

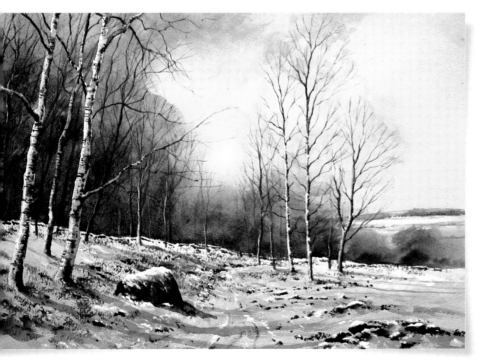

Froggatt Woods in Winter

61 x 40.5cm (24 x 16in)

This larger painting was made on paper I tinted at home. To tint the paper yourself, soak a sheet of 300gsm (140lb) paper in a bowl of cold tea for about twenty minutes, then tape it down to a drawing board using gum-strip tape, as though stretching the paper. Once it has thoroughly dried, the result will be a nice taut, flat surface tinted in a light fawn colour.

This might seem like alot of messing about, but it can be fun sometimes to experiment. The density of the tone can be changed according to how long you leave it to soak, and how strong you make the tea solution.

Paint colours: quinacridone gold, aureolin, cobalt blue, viridian, French ultramarine, burnt sienna, rose madder, Naples yellow

Brushes: masking fluid brush, size 16 round, size 6 round, size 4 round, size 2 round, size 10 round

Other: masking fluid, bar of soap, tracing number 18

Parkland in autumn

Shadows are important to create the impression of form. As well as shadows that appear on the trees themselves, remember that the trees will cast shadows on the areas around them. This exercise will let you practise suggesting the lay of the land.

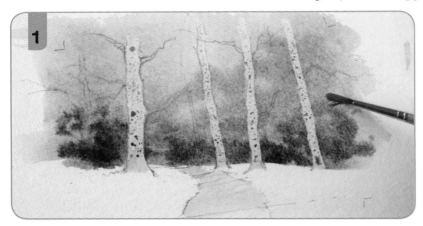

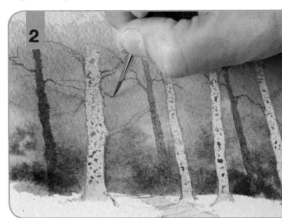

1 Mask out the path and the trees as shown. Once dry, paint the background with a variegated wash: start with quinacridone gold then, working wet-in-wet, add a bright green mix of aureolin and cobalt blue, and a blue-green made from cobalt blue and viridian. Keep these additions nearer to the middle and bottom of the area. Drop in a dark green mix of viridian, French ultramarine and burnt sienna using a size 4, adding these touches right at the bottom. Warm the quinacridone gold by adding burnt sienna and drop in some touches across the middle and top of the wet background area, then allow to dry.

2 Add the distant trees using the size 2 round and a grey mix of cobalt blue, rose madder and burnt sienna. Vary the consistency to create a sense of recession. Use the tip of the brush to add fine branches to the background trees with similar consistencies to their trunks. You can create particularly distant trees by using a very dilute version of the mix and applying the paint with the side of the brush. This will create faint, broken lines.

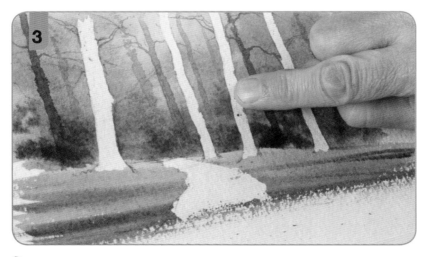

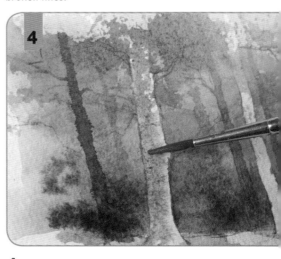

3 Paint the grass using a size 10 round and the orange mix of quinacridone gold and burnt sienna to add horizontal strokes. Introduce the bright green (aureolin and cobalt blue) below that wet-in-wet, then more of the orange mix at the bottom. Add some dark areas with the dark green mix (viridian, French ultramarine and burnt sienna). Once dry, remove all of the masking fluid with a clean finger.

4 Begin painting the foliage using the dry brush technique and the size 6 round to apply a purple mix of rose madder and cobalt blue around the top of the painting. Repeat the process with the orange mix, then a mix of lemon yellow and quinacridone gold.

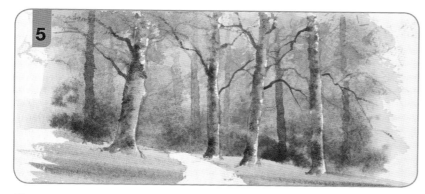

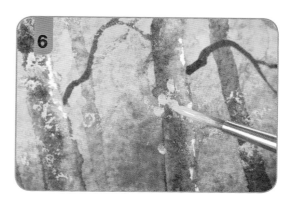

5 While the foliage is wet, add the shadow mix with a size 4 round to the trunks of the trees; then add the orange mix wet-in-wet. Add more burnt sienna to the dark green mix to make it strong and dark and use this wet-in-wet to shade the trunks further. Leave white on the right-hand sides as a highlight, and break up the strokes near the tops to fit in around the foliage. Use the tip of the size 2 round to add fine branches with the dark mix as you work. Some of these should cross the distant trees in order to help the viewer place the larger trees in front.

6 Allow to dry, then add autumnal leaves in front of the trees using a mix of Naples yellow and quinacridone gold, applying the paint with the size 6 brush and the dry brush technique. Pick out some larger highlights of the same mix with the tip of the size 2 brush.

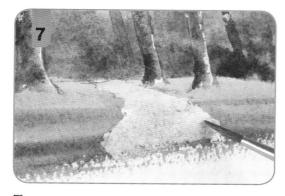

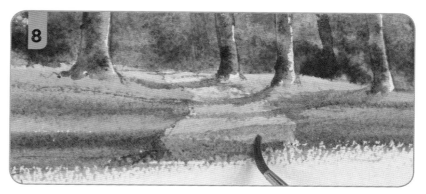

7 Add the path with a dilute mix of quinacridone gold, with a mix of cobalt blue and rose madder added wet-in-wet.

8 Once dry, add the suggestion of scattered leaves on the edges of the path using the tip of the size 2 brush and a mix of burnt sienna and quinacridone gold, along with some stronger purple shadows across the grass the path using the size 4 round.

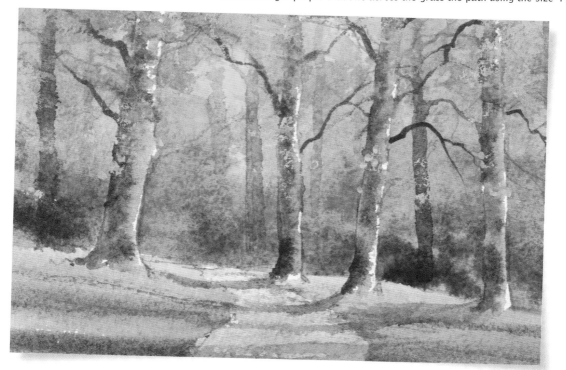

Low winter sun

YOU WILL NEED

Paint colours: cobalt blue, light red, raw sienna

Brushes: size 16 round, size 10 round, liner/writer, size 2 round, size 4 round

Other: putty eraser, tracing number 19

Make sure the pencil lines are very faint for this subtle misty painting – if necessary, use a putty eraser to knock them back until they are only just visible.

1 Before you begin, mix a warm grey from cobalt blue and light red; a wash of cobalt blue; and an orange made from raw sienna and light red. Wet the whole painting area with the size 16 round brush and clean water. Change to the size 10 round and drop in the orange mix in the centre to create a warm glow. Drop in the cobalt blue around the edges, then add the warm grey to create variety, applying this mainly nearer the bottom of the painting. Allow to dry.

2 Use the liner/writer brush to paint the rearmost trees with a dilute pale grey mixture of light red and cobalt blue. This brush holds a lot of paint, which means you can paint each tree in just one or two strokes, which helps to give a clean look. At the base of each tree, use clean water to soften the colour away to nothing, to give the appearance that the bases are hidden in mist.

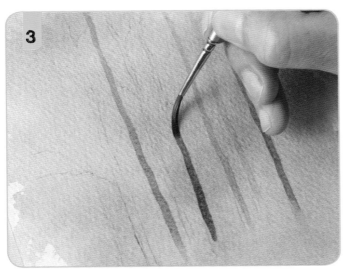

3 Gradually strengthen the mix for each tree – the intention is to suggest that the trees are a variety of distances away, and this relies on your building up the tones very subtly and gradually. The lighter the tone, the further away it will appear.

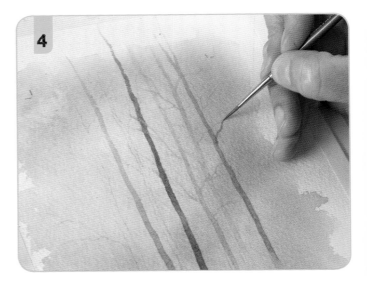

4 Use the tip of the brush to add fine branches. Be careful to match the strength of tone to the trunk of the tree.

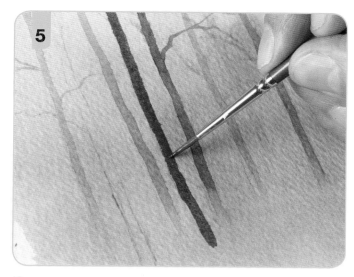

5 Use a thin wash of raw sienna and burnt sienna, and a medium strength grey mixed from cobalt blue and light red, to build up the closer trees. Apply the grey with the liner/writer and add warming touches of the orange-brown mix (raw sienna and burnt sienna) wet-in-wet with the point of the size 2 round.

6 Switch to the size 4 round to apply the larger trees that are closest to the viewer, then add a few lower branches to the foreground tree to finish.

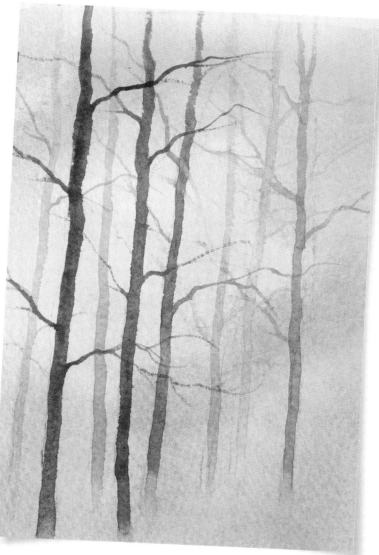

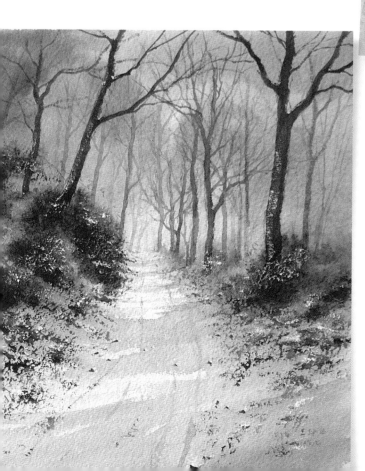

Winter Woodland

25.5 x 33cm (12¼ x 13in)

This could be almost anywhere – a simple path through a wooded area is a classic image. Again much of this painting is about light, with that warm wintery afternoon glow. Notice how the shadows cast by the trees have been employed to describe the dip in the path, caused by the drifting snow.

LIGHT, MOOD AND ATMOSPHERE

YOU WILL NEED

Paint colours: raw sienna, burnt sienna, cobalt blue, light red, French ultramarine

Brushes: size 16 round, size 10 round, size 4 round, liner/writer

Other: tracing number 20

Early morning mist

Mist adds an atmosphere of mystery to any piece. Here, a path disappears into the mist, creating an evocative result.

1 Prepare a thin brown wash of raw sienna and burnt sienna; a cool grey of cobalt blue with a little light red; a warm grey of light red with a little cobalt blue; and a dark mix of burnt sienna and French ultramarine. Wet the whole picture with the size 16 round brush and clean water. Change to the size 10 round brush and drop in the cool grey in the upper two thirds, avoiding the centre of the painting and the middle at the top. Add the brown wash at the bottom, wet-in-wet.

2 Drop in the warm grey at the sides to join the cool grey upper part with the brown wash at the bottom. This helps to draw attention to the centre of the painting.

3 Extend the colour across the bottom as shadow, then change to a size 4 round to drop in small areas of the dark mix, fitting it mainly around the sides to further frame the light central area. Allow this to dry naturally – don't be tempted to speed up the drying with a hairdryer, particularly for a project like this, as the soft, misty effect relies on the colours continuing to blend and merge over a period of time.

4 Once completely dry, pick up more of the cool grey using the liner/writer brush and add some slim trees using the glazing technique – i.e. applying very dilute paint that overlays but does not obscure the area it covers. Paint the trees in the light central area with an even more dilute mix.

5 Strengthen those at the sides with a little of the warm grey mix, added wet-in-wet to help them blend into the existing colour.

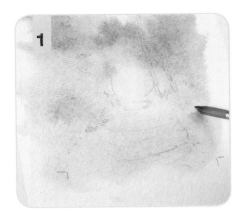

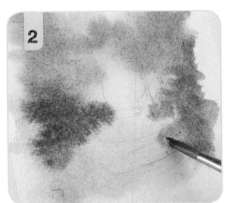

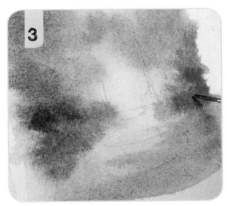

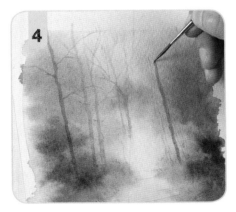

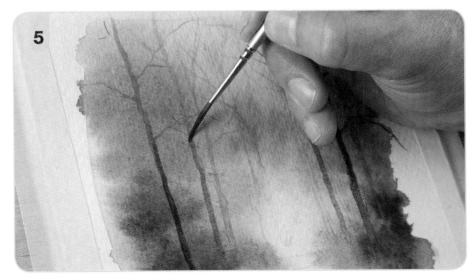

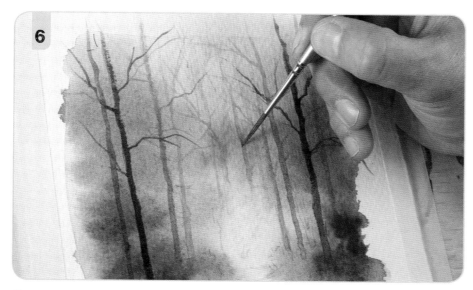

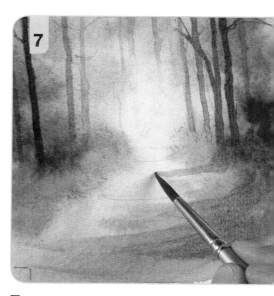

6 Add some further faint trees in the distance using the cool grey mix and the liner/writer. The bases of these should be completely lost in the mist; fade them out well above the ground line by using clean water to soften them away entirely.

7 Add a few shadows across the path using the same cool grey mix.

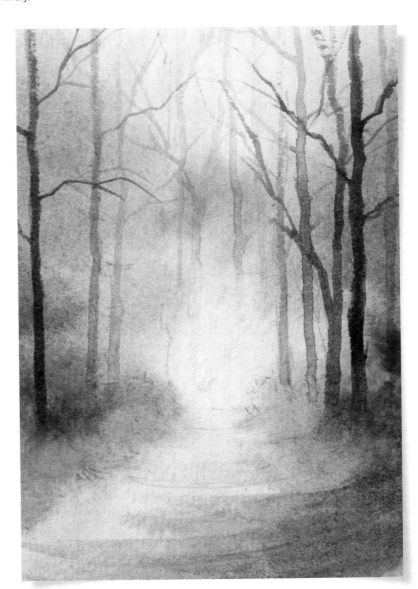

The painting is complete at this point, but we revisit it in the exercise on pages 86–87 to add figures.

YOU WILL NEED

Paint colours: Naples yellow, light red, cobalt blue, rose madder, burnt sienna

Brushes: masking fluid brush, size 16 round, size 10 round, size 2 round, size 6 round, size 4 round

Other: masking fluid, bar of soap, craft knife, tracing number 21

Looking into the light

This exercise gives you practice in using shadows to describe the contours of the landscape, and can also be useful for emphasizing perspective. Notice how the converging lines of the shadows lead the viewer's eye past the foreground trees and into the woods. You should always guard against making shadows too strong, as it should appear as though you can see the land beneath them, through the transparent colour.

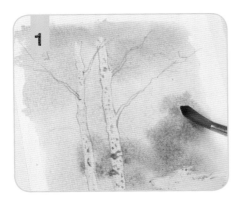
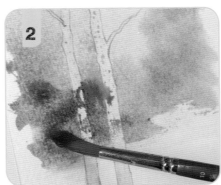
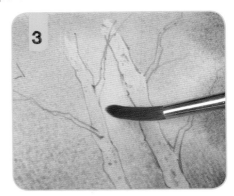
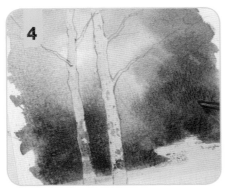
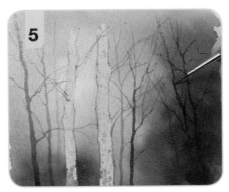
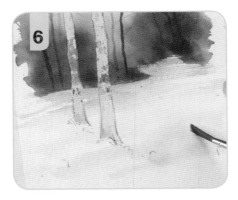

1 Mask out the main trees and the sloped area where the land meets the woods. Wet the background from the top down to the masked-out bank using the size 16 round brush. Use the size 10 round to drop in a wash of an orange mix made from Naples yellow and light red over the whole background. Working wet-in-wet, add a thin purple wash of cobalt blue and rose madder at the top, then drop in a grey mix of cobalt blue, rose madder and light red further down to represent background trees.

2 Add a brown mix of cobalt blue, burnt sienna and rose madder wet-in-wet at the base of the trees using light, dabbing, textural touches of the size 10 brush.

3 Clean and dry the brush and lift out a little colour from the centre, behind one of the trees. This is the light source.

4 Add a little more of the dark mixes in wet-in-wet around the edge of the woodland, then allow the painting to dry.

5 Use the size 2 round brush to add some background trees using the grey and brown mixes. Vary the intensity of the tone by adding water (or more paint) in order to create variety amongst the trees and suggest that some are further away than others.

6 Remove the masking fluid from the woodland, but leave it on the main trees. Use a dilute mix of cobalt blue and rose madder to add quick, light shadows over the revealed area with the size 6 round. Soften the brushstrokes in on the bank itself to create a smoother effect.

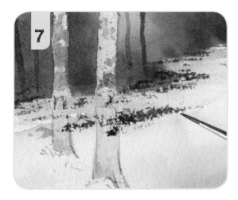
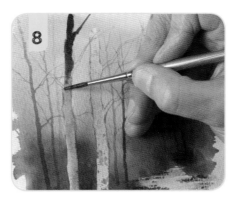
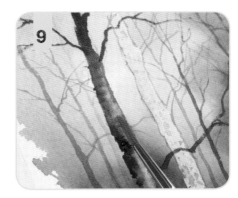
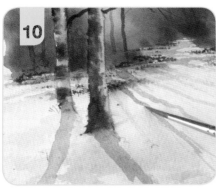
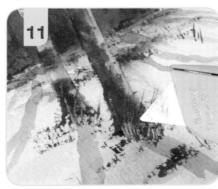
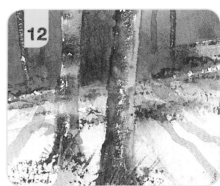

7 Use the dark mix fairly strongly (add more paint if necessary) to suggest the stones, weeds and so forth on the snow using the size 2 round brush and the dry brush technique. Keep these marks close to the wooded area – that is, don't add them across the whole foreground – and angle them so they follow the slope. Add raw sienna and burnt sienna to the mix to warm it, and develop the existing marks a little more.

8 Remove the masking fluid from the tree on the left and use the size 4 brush to paint it with the orange wash, before dropping in the grey mix. While it is still wet, bring in some of the dark mix (cobalt blue, burnt sienna and rose madder) from the top, working down from the edge of the painting into the tree.

9 Change to a size 2 round brush and add smaller details on the bark and a few fine branches with the same mix. Lift out a little of the wet paint on the front of the tree trunk using a clean, dry size 4 brush.

10 Remove the masking fluid from the second tree and paint it in the same way. Once complete, use the purple wash (cobalt blue and rose madder) and the size 2 round brush to add some cast shadows to the foreground. These should extend from the bases of the trees, and point directly away from the light source (see step 3).

11 Use the brown mix and the size 2 round brush with the dry brush technique to add some details around the base of the trees, then use the point of the brush to add a few flicking strokes to suggest grasses. While the paint remains wet around the base of the trees, use the blade of a craft knife to lightly flick the paint up and scratch out the colour.

12 To enhance the effect, wet a size 4 round brush and re-wet the light source, then lift out a little more paint with some clean kitchen paper. Once dry, restrengthen the silhouette of the right-hand tree with the point of the size 2 round and the dark brown mix. Finally, add a few touches of white gouache as eye-catching flecks of snow.

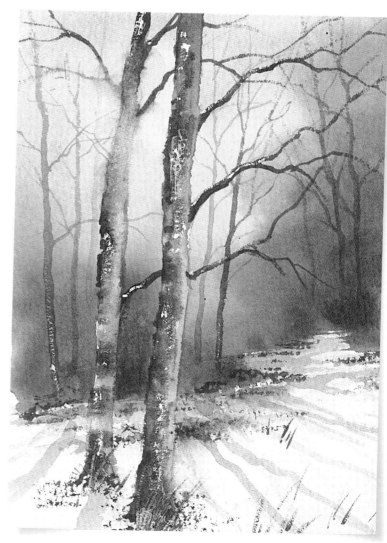

YOU WILL NEED

Paint colours: quinacridone gold, cobalt violet, cobalt blue, viridian, burnt sienna

Brushes: masking fluid brush, size 16 round, size 10 round, size 6 round, size 2 round, size 4 round

Other: masking fluid, bar of soap, tracing number 22

Dappled sunlight

The purple and orange colours used in this painting are complementary. As a result, when they are combined, they turn an attractive grey; but when placed next to each other unmixed, they set each other off, causing both to appear more vibrant. As you paint the foliage, look for areas where you can place these two colours close together without them mixing. This will increase the vibrancy of your picture.

1 Mask the path, then wet the whole top two-thirds of the painting, then switch to the size 10 round brush. Use this to paint the area with a thin wash of quinacridone gold, then add a purple mix of cobalt violet with a little cobalt blue wet-in-wet, concentrating it behind the trees and on the lower left, leaving the top right area with a warm glow.

2 Allow to dry. Mix viridian with cobalt blue to make a blue-green mix; and quinacridone gold with burnt sienna for an autumnal copper-red mix. Indicate broken foliage using the size 6 round, the dry brush technique and the cobalt violet and cobalt blue mix.

3 Add the copper red mix and dilute lemon yellow towards the centre, then gradually introduce the blue-green mix. Where the paper is dry, you will get harder dry brush marks, but where parts remain slightly damp, you will get a softer wet-in-wet appearance.

4 Continue building up the foliage, concentrating the cooler, lighter tones on the right-hand side, and the stronger, warmer tones towards the left.

5 Without waiting for the paint to dry, pick up the cobalt violet and cobalt blue mix on a size 2 round brush and begin to add the trunks of the trees.

6 Dilute the paint for more distant trees, and remember to break the lines a little to suggest intervening foliage.

7 Add burnt sienna to the mix for closer trees, with quinacridone gold wet-in-wet for warmth. You can add touches of this on the still-wet midground trunks to help 'bridge the gap' between the foreground and background trees.

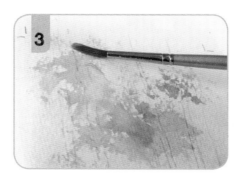
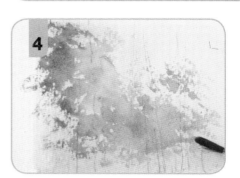
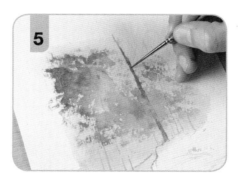
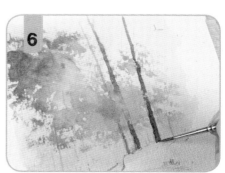
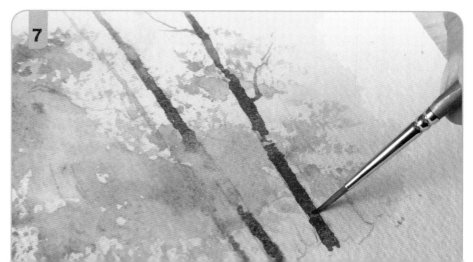

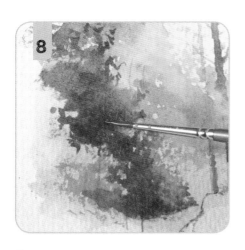

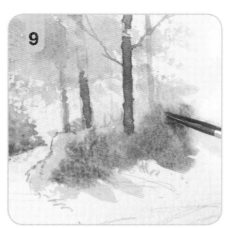

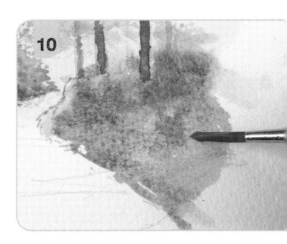

8 Continue building up the trees, adding fine branches with tapering strokes of the size 2 round. Use the dry brush technique to apply the copper-red mix with the size 4 round to the area above the masked-out path. Touch in the cobalt violet and cobalt blue mix, and an orange mix of quinacridone gold and burnt sienna with a size 2 round while the colour remains wet.

9 Use the size 4 round to apply the orange mix and begin to build up the bank on the right-hand side of the painting, then drop in the purples and greens on your palette.

10 Continue building up the bank down to the path, adding hints of lemon yellow wet-in-wet and finishing with a mostly green area.

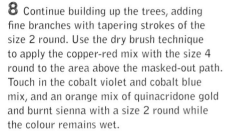

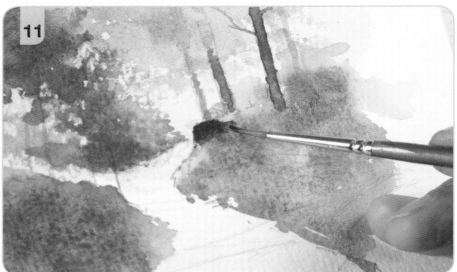

11 Paint the left-hand bank in the same way using the mixes on your palette. Allow the painting to dry, then mix burnt sienna and cobalt blue. Use a size 2 round brush to paint the large rock on the right-hand bank. The top edge should be sharp, but soften the bottom into the bank with a clean damp brush.

12 Mix burnt sienna with French ultramarine and cobalt violet for a warm dark. Paint in the largest tree trunk with a size 4 round brush. Dash it in fairly quickly, allowing the colour to break up towards the top of the stroke. Rinse the brush and soften the roots into the bank with the damp bristles.

13 Dilute the mix and repeat the process for the foreground trees to the left of the main tree.

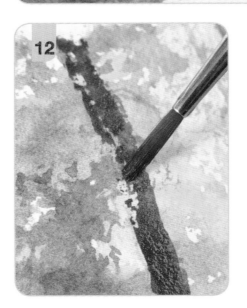

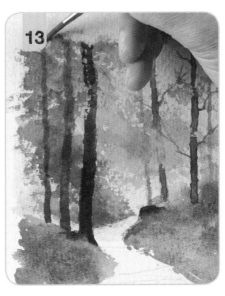

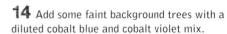

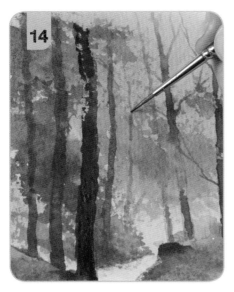

14 Add some faint background trees with a diluted cobalt blue and cobalt violet mix.

15 Mix lemon yellow with quinacridone gold to make a warm opaque yellow-orange. Use this to hint at leaves on the left-hand side with the tip of the brush and also with some dry brush work.

16 Continue this over the right-hand side, using just dry brush work – these trees are too distant for the individual leaves to 'read'. Break up the edges of the path with the same mix, to prevent it looking too clean and sharp. Allow the painting to dry before going any further.

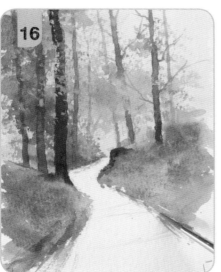

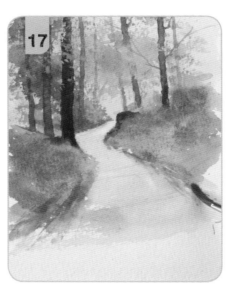

17 Switch to a size 4 round and wet the area where the masking was. Change to a size 6 and wet the remainder of the path, working over the broken edges you just established. Add a dilute mix of quinacridone gold and burnt sienna, concentrating the subtle colour towards the bottom of the painting and leaving the distant path light. Allow to dry.

18 Use the cobalt blue and cobalt violet mix to paint in shadows that work down the bank and across the path, creating a dappled mass of shadow with the size 6 round.

19 Rinse the brush and soften the colour a little with the damp bristles, then introduce a little burnt sienna wet-in-wet at the bottom right of the painting.

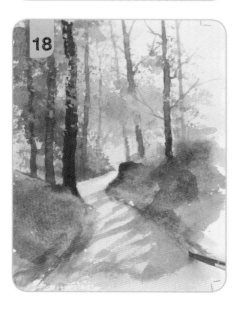

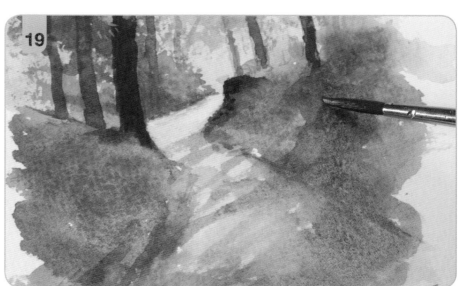

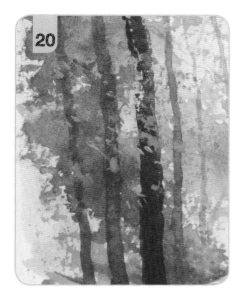

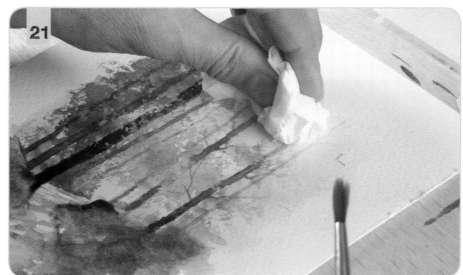

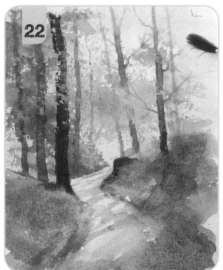

20 Use the size 2 round to add some fine shadows on the distant path.

21 Use a wet size 6 round to dampen the top left of the painting and use a piece of kitchen paper to lift out some of the colour.

22 You can make any tweaks and refinements you like to the painting, but be careful not to overwork it – the bright atmosphere relies on a light touch.

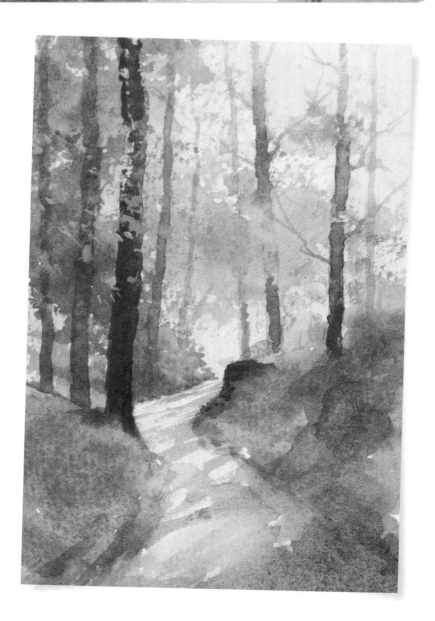

PERSPECTIVE AND COMPOSITION

Learning all the methods relating to colour, technique and use of materials in this book will still not produce a satisfying painting if the basic composition isn't sound; so it is worth considering this aspect of the subject. The use of perspective and composition in landscape painting is far too involved a subject to cover in this one small chapter, but you can avoid compositional pitfalls by observing a few simple guidelines.

I believe it is always a good rule of thumb to think in terms of thirds. For instance, in the painting below we can see that the horizon line is roughly a third of the way up from the bottom. The largest of the dark, vertical shapes of the silhouetted trees is a third of the way in from the left, and forms a strong 'L' shape when we connect it up with the horizon line. This shape is then echoed just right of centre by the thinner, more distant trees. The snow-capped building, seen through the gap between them, creates another point of interest.

All this is underpinned by the linear perspective created by the converging lines of the road, enhanced by the also converging lines of the fences, on both sides of the road.

It is worth bearing in mind that when we think in terms of thirds, it is approximate, and doesn't have to relate to an exact measurement: it is simply about avoiding placing the focal point dead in the centre.

Snowfall
35.5 x 28cm (14 x 11in)

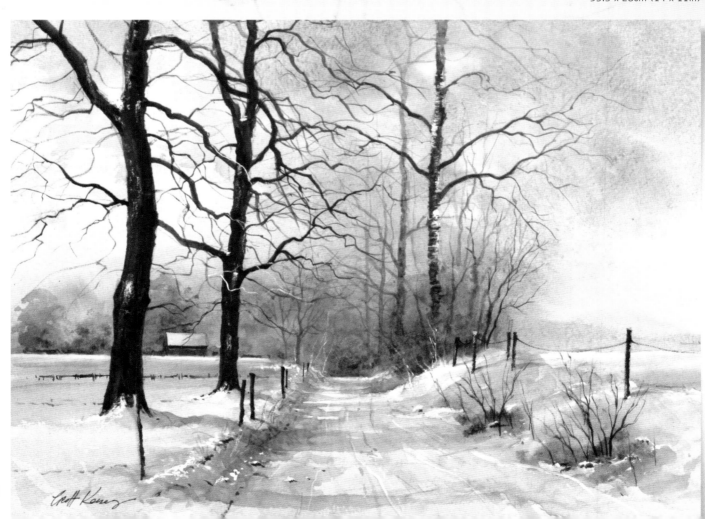

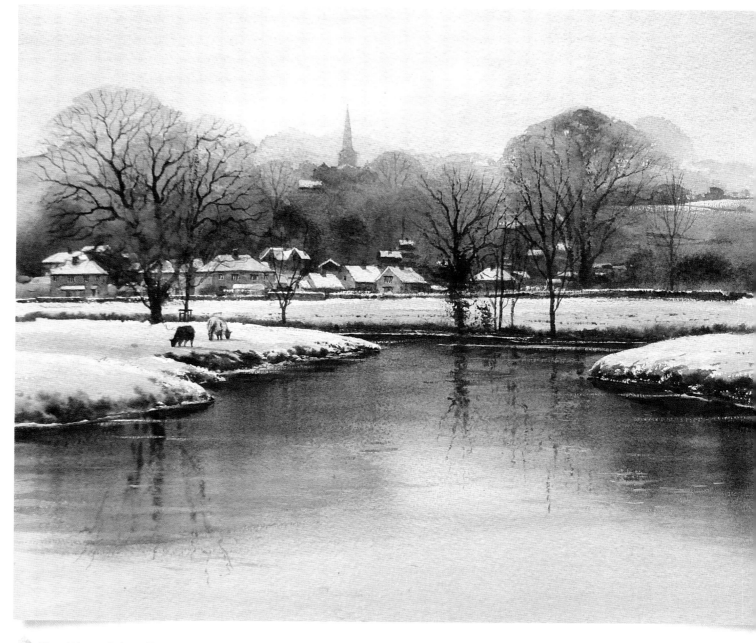

River Wye at Bakewell

56 x 48cm (22 x 19in)

The application of the basic compositional guidelines detailed opposite is less obvious in this very different composition. However, consider the way in which the band of distant trees, and hard shapes of the distant buildings, have been placed roughly a third of the way down from the top. The faint shape of the distant church spire, while not exactly a third of the way in from the left, is deliberately off-centre so it still works compositionally. The dominant tree on the bank in the middle distance appears nearer to us because it is larger and more detailed than those further back on the right. While this still works, in hindsight, I now wish I had painted this tree a little taller to further emphasize this difference and echo the 'L'-shaped composition more effectively.

Unlike *Snowfall*, there are no obvious perspective lines in this painting. Instead, a sense of distance is created by the gradual narrowing of the river. The shapes of the grazing cattle, even though very small, create sufficient interest to lead the viewer into the middle distance. I think the tonal contrast between the white roofs of the houses and the dark tones of the soft tree shapes immediately behind them creates a good focal point, which also invites us into the scene.

Contrast and impact

Contrast, whether in tone, colour, or shape, helps to give a painting impact. What appealed to me about this subject is the contrast between the soft, haphazard shapes of the trees and vegetation, and the harder edge of the man-made structure that is the old viaduct. I also like the lost-and-found element, where we feel we are just glimpsing the structure through the trees; and beyond that, the glow in the afternoon sky through the arches.

Use these photographs and example paintings to practise the techniques learned earlier, applying them with an eye to creating contrast, and to adapting photographs to make the best of them.

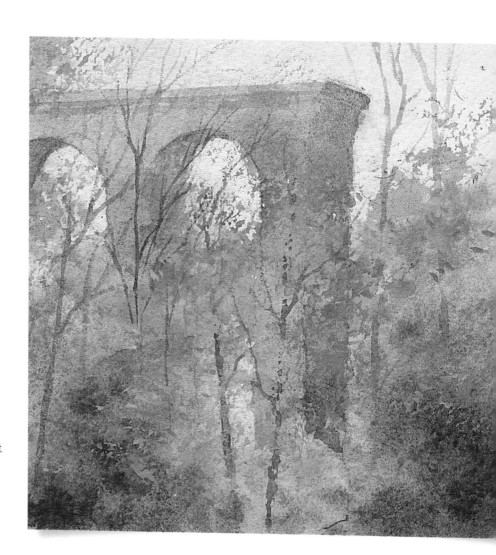

Here I have cut the paper down into a 10 x 10cm (4 x 4in) square format for a change, and I have deliberately placed the viaduct shape in the distance by painting it in a light greyish tone.

I really wanted to exploit the brilliant autumn colour in the centre, so use a strong mixture of Indian yellow with a touch of burnt sienna. If we compare the painting with the reference photograph above, you can see that I left out the big tree trunk that cuts through the centre, as I felt it acted as a barrier.

YOU WILL NEED

Paint colours: French ultramarine, light red, lemon yellow, aureolin, viridian, cobalt violet, raw sienna

Brushes: masking fluid brush, 12mm (½in) flat, size 2 round, size 4 round, size 8 round, size 10 round, size 16 round

Other: masking fluid, tracing number 24

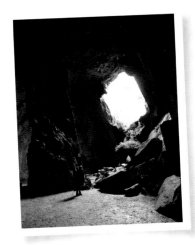

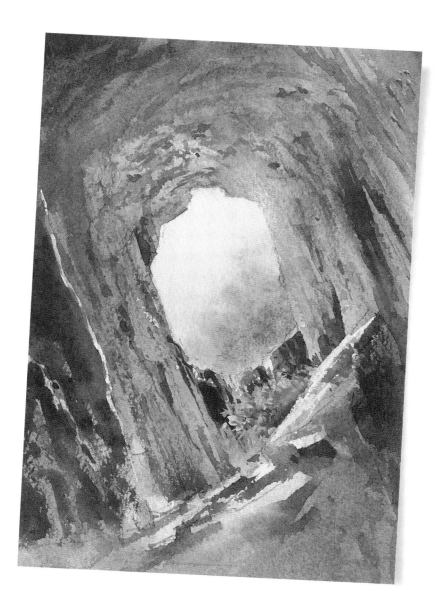

PUTTING IT INTO PRACTICE

This cave, part of an old slate quarry in the Lake District, UK, is called The Cathedral. I love the contrast between light and dark that we get looking out at the trees through the opening. The reference photograph above gave me the idea of using this subject to illustrate the contrast of soft shapes of vegetation with the hard craggy shapes and unique strata of the slate. I was also attracted to the diagonal that runs through the whole subject; ask yourself if this would be as interesting if it was all level.

At the top right-hand edge of the opening, I faded the colour once it had dried, by rubbing over it with a clean, damp size 8 brush.

The greys used in the rock were made from a mixture of French ultramarine and light red. These greys were mixed with a variety of tonal values from light to dark, generally starting off lighter near the opening and darkening as they radiate out from this. The blue/green we can see to the bottom right of the opening is mixed from viridian and cobalt violet, and the bright greens from lemon yellow and a slightly darker green mixed from aureolin and cobalt blue.

Parkland with wildflowers

YOU WILL NEED

Paint colours: cobalt blue, rose madder, burnt sienna, aureolin, viridian, French ultramarine, lemon yellow

Brushes: masking fluid brush, size 10 round, size 6 round, size 2 round

Other: masking fluid, bar of soap, tracing number 25

The trees in this exercise are treated differently from one another depending on their position: the three in the middle distance and the one in the foreground are catching the sunlight and thus will be lighter than their surroundings, so we mask them to protect the clean paper for later. The other trees will be darker than their surroundings, so there is no need to protect them. Awareness of these variables will help you to make more authentic paintings.

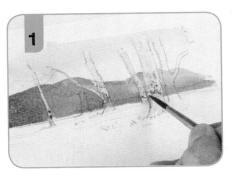

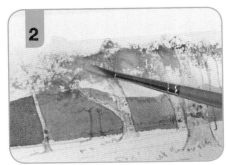

1 Mask out the four trees as shown. Once dry, wet the sky with clean water – the top third of the painting area – and drop in a mix of dilute cobalt blue with a hint of rose madder at the top. Allow to dry, then use the size 6 brush to paint in the distant hill with a grey mix of cobalt blue, rose madder and burnt sienna, working right down to the horizon.

2 Mix a bright green from aureolin and cobalt blue; a dark green from viridian, French ultramarine and burnt sienna. Use the size 6 round with the dry brush technique to add the suggestion of foliage around the trees with the two mixes. Add some brighter foliage with lemon yellow at a single cream consistency.

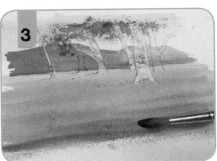

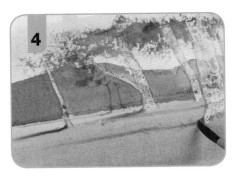

3 Make a second well of the bright green and add a touch of burnt sienna to create an olive green mix. Moving to the middle distance and foreground, paint the distant grass with the size 10 round and the bright green mix. Work the bright green down to cover the whole area, then add the olive green mix over the top from the middle part of the grass down. Do the same with the dark green for the lower part of the grass area.

4 While the paint remains wet, add shadows from the bases of the trees using the dark green mix and the point of the size 10 brush.

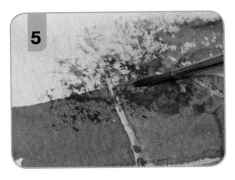

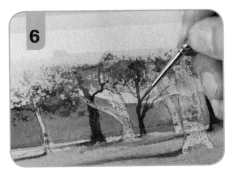

5 Make a brown mix of raw sienna and burnt sienna, and use the size 2 round brush to dry brush a few areas of redder leaves over the midground foliage.

6 Use the grey mix (cobalt blue, rose madder and burnt sienna) to paint in the distant trees. Drop in some of the brown mix (raw sienna and burnt sienna) to warm and vary the tone.

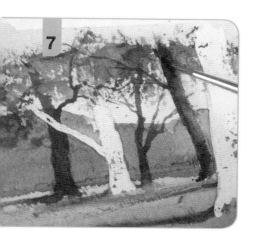

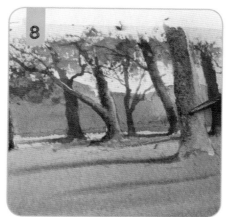

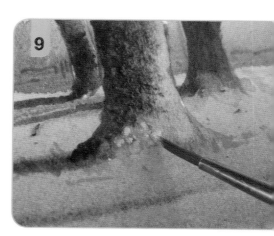

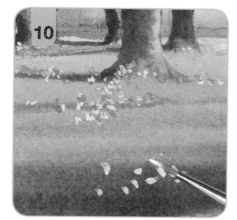

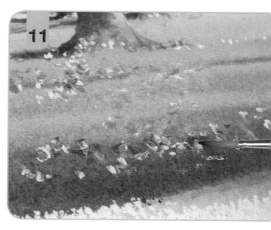

7 Remove all of the masking fluid. Mix burnt sienna, French ultramarine and rose madder to make a rich, warm dark. Use the size 2 round brush to paint the revealed trees with the brown mix (raw sienna and burnt sienna), then drop in the warm dark mix on the left-hand sides.

8 Paint the other unmasked trees in the same way. For the largest tree, nearest the viewer, paint it in a similar way, but add the bright green mix on the left after the initial brown wash.

9 Use the size 2 round to add some tiny touches of lemon yellow wet-in-wet at the base of the large tree to represent grasses and anchor the tree to the ground.

10 Create a few patches of wildflowers with white gouache with groups of tiny flicks of the tip of the brush. Aim for a random effect to create authentic-looking clusters.

11 Mix lemon yellow with burnt sienna and add further marks over the top of the clusters. Do not try to cover each earlier mark directly; just create a loose impression. Make some larger marks in the foreground in the same way, using white gouache.

12 You can continue to add wildflowers by mixing cobalt blue and cobalt violet and tinting the foreground clusters as before; and by adding some yellow marks in the same way.

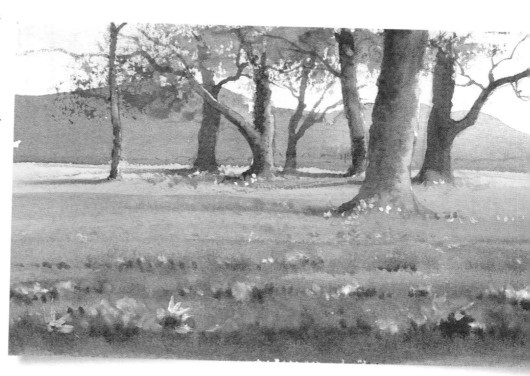

Pond reflections

The best way to create recession is to alter the tone – you can do this by adding more water to your mix for lighter, weaker tones and more paint for darker, stronger tones. This exercise also looks more closely at reflections.

YOU WILL NEED

Paint colours: lemon yellow, aureolin, cobalt blue, viridian, cobalt violet, French ultramarine, burnt sienna

Brushes: masking fluid brush, size 16 round, size 10 round, size 6 round, size 2 round, size 4 round, 6mm (¼in) flat

Other: masking fluid, bar of soap, tracing number 26

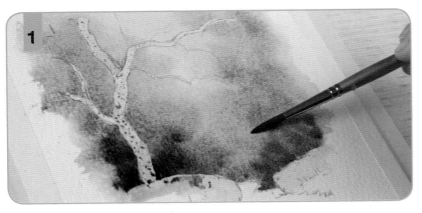

1 Mask the main tree, large rocks and the water. Once dry, wet the background down to the masked-off rocks. Use the size 6 brush to create a variegated wash of lemon yellow and a bright green mix of aureolin and cobalt blue. Add a green-grey mix of viridian and cobalt violet in around the lower half of the background, then add more cobalt violet to the mix and strengthen the darks around the rocks, avoiding the very centre of the image. Still working wet-in-wet, add touches of a dark green mix – viridian, French ultramarine and burnt sienna – within the dark grey areas and allow to dry.

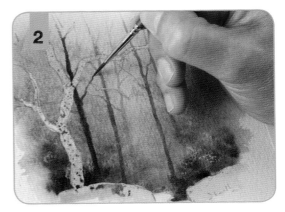

2 Once dry, use the size 6 brush with the dry brush technique to apply the bright green mix and lemon yellow sparingly over the painting. This will break up the background and suggest the texture of the foliage. Allow the background to dry completely, then pick up a grey mix of cobalt blue, cobalt violet and burnt sienna with the size 2 round. Use this at different dilutions to add some simple background trees.

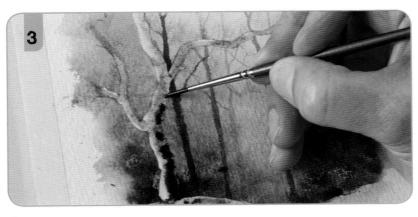

3 Remove the masking fluid from the big tree on the left, but leave it in place on the rocks and water. Prepare a dark brown mix of burnt sienna and French ultramarine, and a shadow mix of cobalt blue and cobalt violet. Change to the size 4 brush and wet the revealed tree trunk and branches. Drop in some of the shadow mix, concentrating on the right-hand side. Touch in some of the bright green mix, then switch to a size 2 round and add some of the new dark brown, again concentrating on the right-hand side.

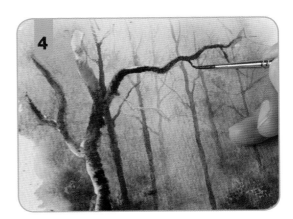

4 Add a hint of lemon yellow wet-in-wet on the left-hand side, then use the dark brown mix to paint the finer branches.

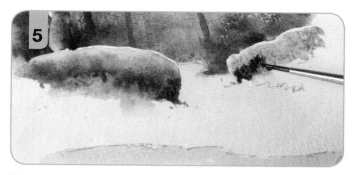

5 Paint a thin wash of raw sienna on the path between the stones using the size 6 round brush. Use clean water to soften it down towards the river. Once dry, remove the masking fluid from the stones before using the size 4 round to wet the stone with clean water. Drop in raw sienna, leaving a thin line of white paper at the top, then add the shadow mix followed by the green-grey mix. While it remains wet, add a mix of burnt sienna and French ultramarine to the lower part. Switch to the size 2 round brush and add a hint or two of lemon yellow to represent foreground grass in front of the rocks.

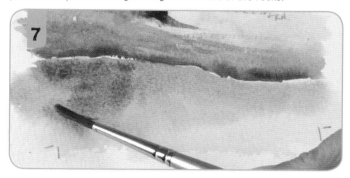

7 Remove the remaining masking fluid. For the water, we will use a repetition of the colours used in the background, so refresh your mixes (see step 1). Wet the whole area, leaving a fine line of dry paper between the water and the bank. Drop in lemon yellow across the whole area with the size 10 round. Add the bright green mix wet-in-wet near the top. Next, change to the size 4 and add the green-grey mix, again nearer the bank. Use the size 6 to add some of the dark green mix as close to the edge as possible without going over the line of dry paper.

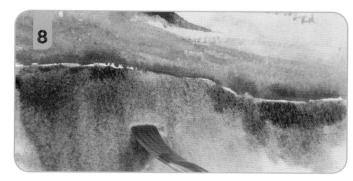

8 Working wet-in-wet, add some of the shadow mix (cobalt violet and cobalt blue) in the water below the stones. Dampen a 6mm (¼in) flat brush and use it with a light flicking motion to draw the wet paint straight downwards from the bank to blend the colours vertically. Make sure the strokes are perpendicular.

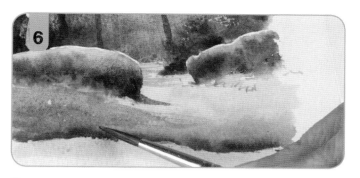

6 Use the size 10 round to re-wet the path down to the water's edge, then drop in some raw sienna. Drop in some of the shadow mix with a size 6. Swap to a size 2 round brush and drop in some of the burnt sienna and French ultramarine mix on the very edge of the bank before adding more of the shadow mix across the path.

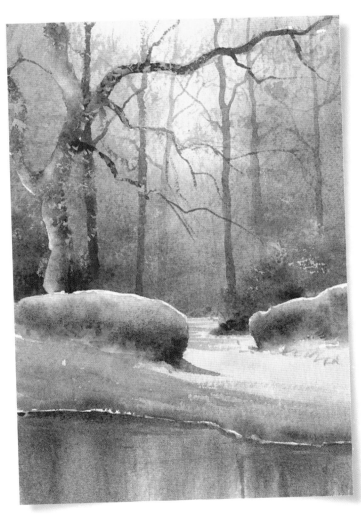

9 Use vertical strokes of a dilute cobalt blue, cobalt violet and burnt sienna mix to add reflections of the trees, then add a dark line that follows the edge of the water with the same brush and mix to finish off the painting perfectly.

Adding figures

YOU WILL NEED

Paint colours: burnt umber, raw sienna, cobalt blue, French ultramarine, light red

Brushes: size 10 round, size 6 round, size 4 round

Other: 2B pencil, tracing paper, craft knife, tracing numbers 27 and 20

Figures are a great way to suggest scale. They provide an opportunity to introduce a flash or splash of eye-catching colour that helps to draw the viewer's eye to a focal point. They can also be painted as silhouettes for a more muted and subtle result, as shown here. This is particularly effective in adding more atmosphere to your paintings.

Tracing 27 is of the figures alone; the rest of the painting is made using tracing 20 and the instructions on pages 70–71. Using these tracings in combination will ensure the scale and positioning are correct. Feel free to copy the figures and use them in different paintings to practise.

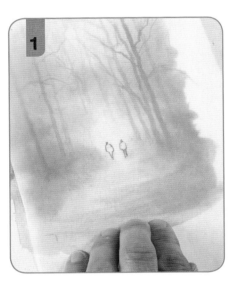

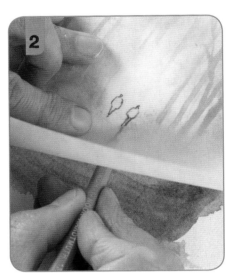

1 Trace the figures onto a piece of tracing paper using a 2B pencil. Place the tracing paper over your painting and make sure you are happy with the position.

2 Hold the paper in position, lift the bottom and make a mark on your painting just below the figures' feet.

3 Turn the tracing paper over and put it on a spare bit of scrap paper. Scribble lightly over the back with your pencil.

4 Reposition the tracing so the figures sit over the marks and secure it in place with a little masking tape.

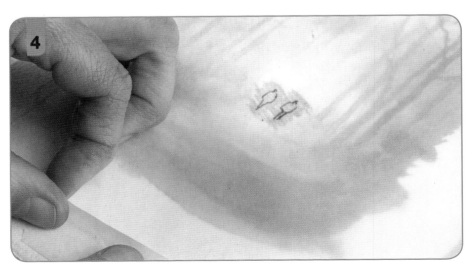

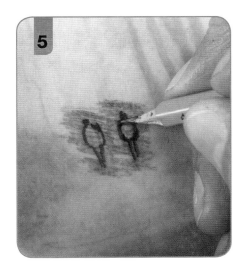

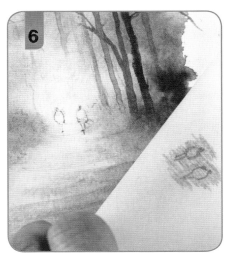

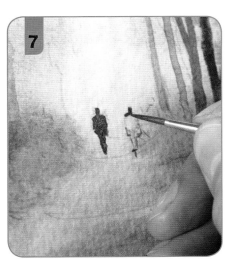

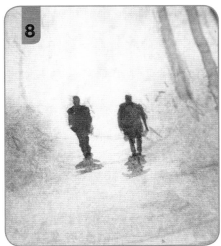

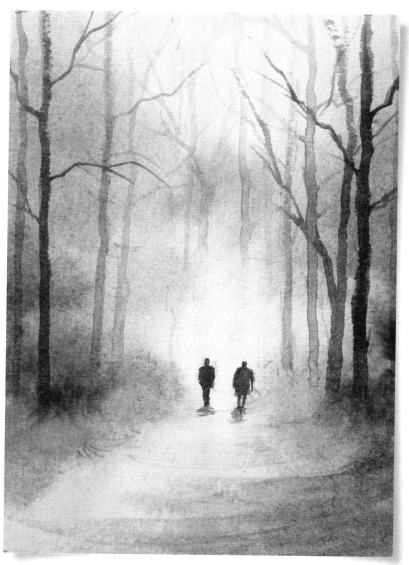

5 Carefully draw over the outline of each figure to transfer the image.

6 Peel back the tracing to reveal a faint outline of the figures.

7 You can now paint in the figures. In this instance, I am using colours sympathetic to the overall palette and keeping them as silhouettes. Because the figures are silhouetted, I wanted a rich dark colour, so I chose a mixture of burnt umber and French ultramarine. The shadows were put in with the same grey as used in the sky, a mixture of cobalt blue and light red.

8 It is important to ground the figures in the painting, so be sure to include a shadow. This can be added with a more dilute version of the same mix.

YOU WILL NEED

Paint colours: Naples yellow, light red, cobalt blue, burnt sienna, white gouache, French ultramarine

Brushes: masking fluid brush, size 16 round, size 10 round, size 6 round, size 4 round, size 2 round

Other: masking fluid, bar of soap, tracing number 28

Winter lane

This exercise looks at recession along with the creative use of opaque white gouache. It is also a good example of the importance of making trees look individual. When adding the branches, try to avoid adding them directly opposite a branch coming from the trees on the opposite side. Even if it is there in real life, in a painting it can look contrived.

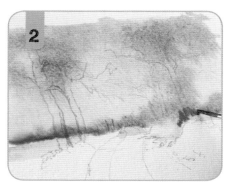

Technique: Opaque whit

Opaque body colour is usually applied to the dry surface to reinstate or create highlights, but here it works beautifully to create the softness of snow in the middle distance when applied wet-in-wet.

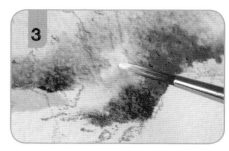

1 Mask fine lines along the far left and far right of the horizon, and on the distant path. Wet the background down to the horizon line with the size 16 round, then drop in a very thin wash of a Naples yellow and light red mix above the horizon. Add thin cobalt blue wet-in-wet at the top. Allow the paint to dry a little, then drop in touches of a neutral grey mix made from cobalt blue and light red along the horizon with the point of the size 6 brush.

2 Add some more red to the neutral grey mix to warm it, and drop it in around the tops of the trees. Switch to the size 4 brush and make a strong grey from cobalt blue and burnt sienna. Strengthen the colours around the base of the trees on the right-hand side.

3 Still using the size 4 round brush, add some touches of white gouache wet-in-wet over the lower part of the right-hand trees.

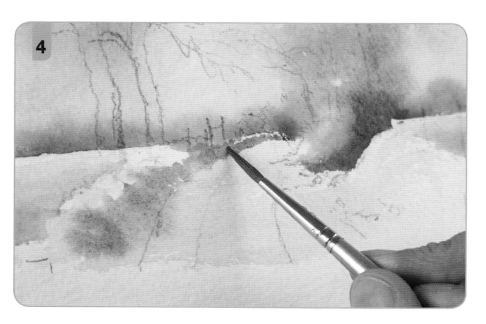

4 Once dry, remove the masking fluid. Add snow shadows across the foreground fields on both sides using the thin cobalt blue wash and a size 6 round brush. As the area approaches the hedges, bring in the stronger neutral grey wet-in-wet. Add more tone to the lower part of the sky by wetting it with clean water and the size 6 round. Drop in neutral grey. Use the size 6 round brush to add dilute cobalt blue across the road, softening it in with clean water. Switch to the strong neutral grey to add some stronger tone and colour on the banks on either side of the road. Be careful to leave a thin sliver of clean white paper at the top – this is important to show the clean white snow on the top.

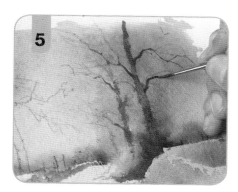

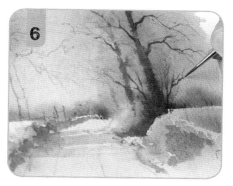

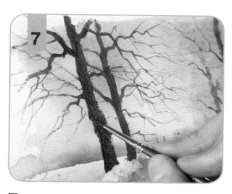

5 With a strong mix of the neutral grey (add more cobalt blue and light red paint), use the side of the size 2 round to add a broken line to represent a background tree. Develop a few branches with the same mix, then strengthen the mix still further and repeat the process with the size 4 round brush for the larger midground tree on the right-hand side. Switch to the size 2 round for the main branches.

6 Use the same mix to develop the foreground area with additional shading and cast shadows across the road. Apply these last with horizontal strokes. Use the very tip of the size 2 round brush to add the fine branches of the small bush in front of the large tree with the same mix.

7 Repeat the process with the tree on the left-hand side of the path, using a stronger grey mix made of burnt sienna and cobalt blue. For the leftmost tree, use a still stronger mix of burnt sienna and French ultramarine to make it appear a little nearer.

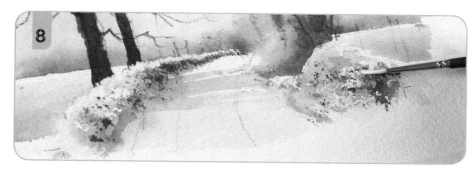

8 Use a dry brush technique with the same mix for some foreground detailing around the hedgerow, using the size 2 brush on its side. Once dry, use the tip and side of the size 2 round brush to add touches of white gouache to refine the existing highlights in the foreground.

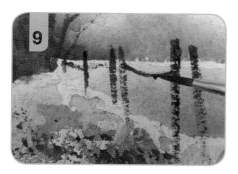

9 Add subtle touches of snow to the main trees with white gouache, and a few fenceposts and wire in the foreground with using the dark grey mix. Use a nearly dry brush for the posts, as the drag this creates will suggest a little texture.

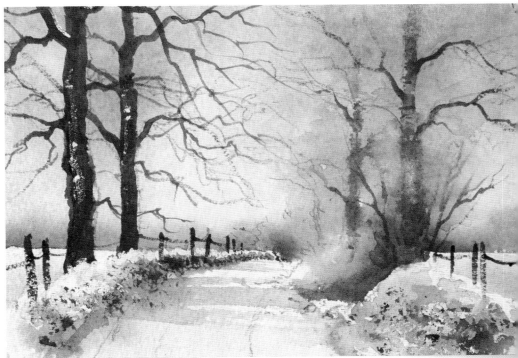

LOOKING DOWN TO MATLOCK

See tracing number 29

For this scene I chose a high vantage point so that I was looking down on the subject, with the road describing a curve that leads the viewer's eye through the composition.

The boxy shapes of the row of buildings on the right-hand side of the road contrast well with the mass of foliage and vegetation on the steep bank behind them. To ensure that I still had plenty of white paper for the buildings after I had painted the background, I applied masking fluid to them right at the outset.

The reflections in the river on the left, as it runs parallel with the road, serve to frame the winding shape. In the foreground, the much larger rooftops I am looking down upon give us a sense of perspective, and the whole subject is framed by the large branch and colourful autumn leaves in the top left. Consider what the painting would look like without this branch and leaf detail, and I hope you will agree that it is a very important part of the composition.

In addition to the masking fluid on the buildings, I also applied masking fluid to some of the large leaves in the top left, supplementing these at the end of the painting with some opaque colour. For more information about using opaque, or body colour see page 88.

The autumnal colours were aureolin and burnt sienna, raw sienna and burnt sienna, plus a dark brown made from burnt sienna and cobalt blue.

The impression of the mass of trees on the steep bank behind the buildings was painted very loosely, by just brushing the rich autumn darks into a wet background, to maintain the soft shapes. For these rich autumn darks I mixed a dark green made from viridian, French ultramarine and burnt sienna, plus a cool grey green made from a mixture of viridian and cobalt violet.

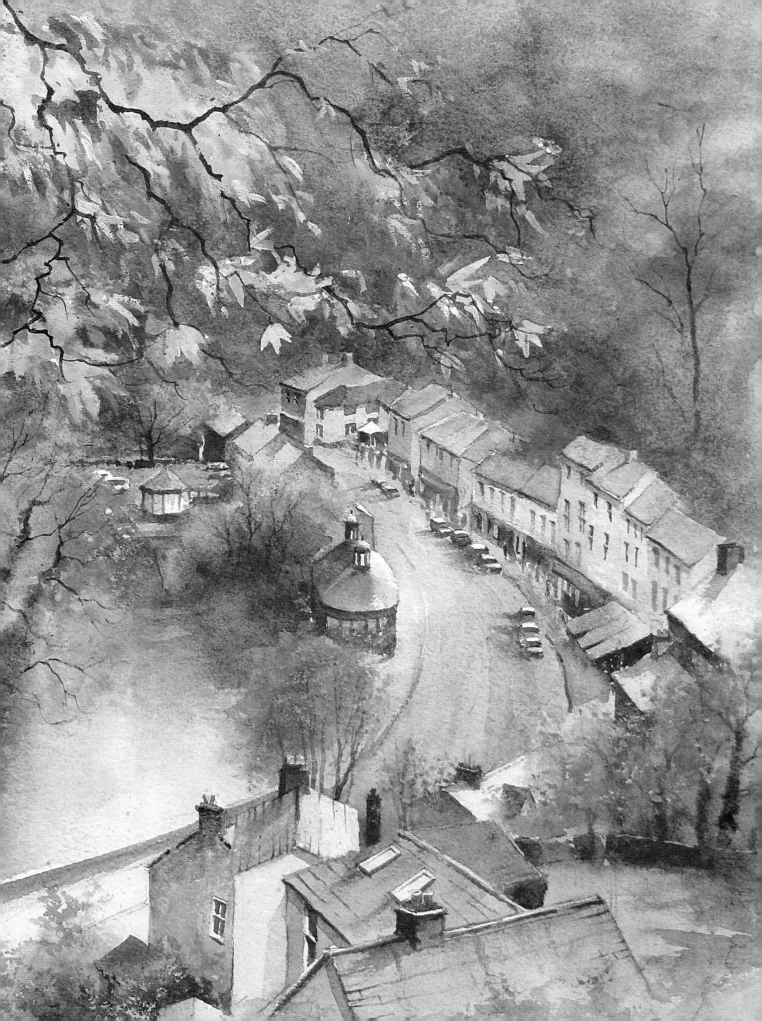

BRIDGE OVER THE OLD CANAL

See tracing number 30

Every now and again I come across a subject that I feel lends itself to the square format I used here. The source photograph I used was rectangular – as is often the case – but I felt that the detail in the parts cropped from the final piece detracted from the composition. You should feel free to do a similar bit of mental editing to your photographs.

I was drawn to the bright light on the far bank just through the arch, and the way the bright yellow contrasted with the dark shadow on the underside of the arch. I believe the arch and view just beyond it are in fact the focal point, and as such I have used this contrast, of tone and colour to give maximum impact to it.

I chose a palette made up primarily of purple and green; using quite strong greens made from various viridian-based mixes: the viridian being variously combined with cobalt violet, with French ultramarine and burnt sienna, and occasionally with a touch of cerulean blue. It is well worth experimenting with swatches of these colour schemes on a separate piece of paper before starting the actual painting. This will familiarise you with the colours and how they act together on the paper, and could also help you to avoid getting the viridian too strong. It is a great colour to have in your palette but you have to learn to control it.

The tall trees on the other side of the bridge were initially put in with dry brushwork as described in the exercise on page 15. Note also how fine the subsequent branchwork is. The vegetation to the left of the path was painted after using masking fluid on a wet background, as described on page 22.

Rather than use greys in the stonework for the bridge and building I have made these a warmer, more violet colour, using combinations of cerulean blue and cobalt violet and cobalt blue and cobalt violet. These purples and greens calm each other down because they are complementary. This emphasizes the brightness of the autumn foliage, which was brushed in with mixtures of lemon yellow, Naples yellow and Indian yellow.

Having this as the focal point works well compositionally, as the arch is a third of the way in from the right, and a third of the way up from the bottom. Coupled with the vertical edge of the house (see main image), the bridge also makes use of the L-shape. These compositional tools are described on pages 78–79.

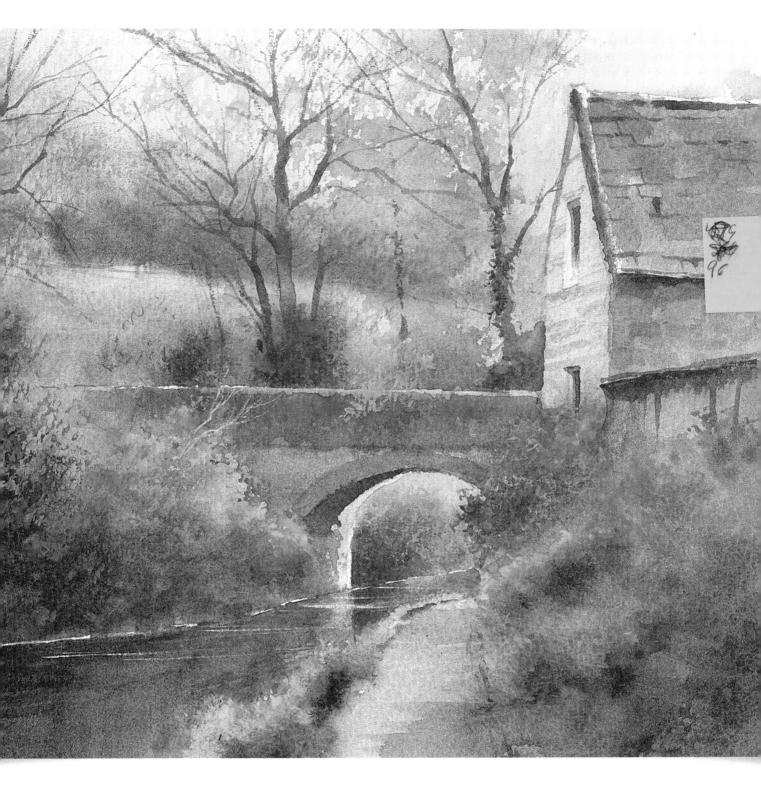

TISSINGTON SPIRES

See tracing number 31

Tissington Spires are a series of rock formations in a place called Dovedale, in the Peak District National Park, not far from where I live. The spires are formed from limestone, made up of the remains of sea creatures. Whenever I am walking in this area, I find it incredible to think that it was once at the bottom of the ocean. There is more evidence of this in the stone steps at various stages along the path (which I understand was constructed by Italian prisoners of war) where you can actually make out the shapes of the sea creatures from their fossilised remains.

However, that isn't why this area inspires me; instead it is the way the impressive craggy, rough, stone structures rise up from the soft misty shapes of the winter trees. Even though there is a lot of grey in this scene I have tried to keep to warm greys, mixed basically from cobalt blue, light red and a touch of rose madder.

The soft light in the sky was brushed in with Naples yellow mixed with a touch of light red and this same colour was used to render the soft tree top shapes, which gradually hide the structures of the rocks. The trees were then put in with a dark mixture of burnt sienna mixed with French ultramarine.

One of the things that makes this scene unusual is that the trees, for once, aren't the tallest aspect. These limestone structures are truly huge, and when you approach this painting, you might consider emphasizing their size by including a figure or two to give the viewer more of an idea of scale.

The transition between the remaining foliage of the wintry trees and the stronger branches and spires is at the heart of this painting. It was achieved with the same mix of Naples yellow and light red used in the sky. This adds to the sense of a calm, harmonious painting.

Where you can see lighter-coloured tree detail against the darker background, I have used a fine number 2 brush, with some almost neat, Naples yellow. The rocks I painted with various tones of grey, mainly using dry brush work, to suggest the rough, uneven surface, ensuring that I didn't put too much detail behind the trees; preferring the lost and found effect.

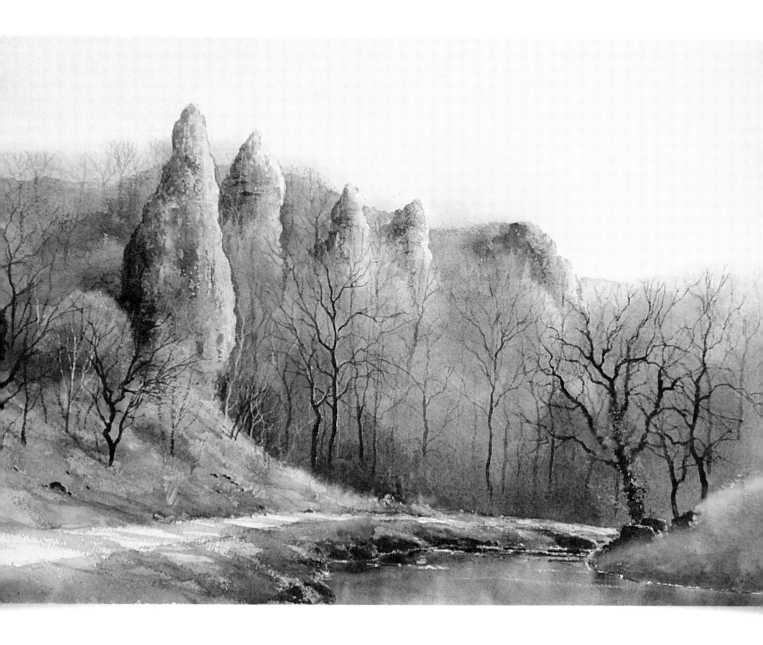

Because this is winter and I wanted a palette of understated colours, I have used quite muted greens on the grass banks at both sides of the path, made from aureolin and cobalt blue, quietened down with a touch of Naples yellow.

INDEX